# WOMEN PIONEERS

# A M E R I C A N
# P R O F I L E S

---

# WOMEN PIONEERS

■

*Rebecca Stefoff*

Facts On File, Inc.

AN INFOBASE HOLDINGS COMPANY

# Women Pioneers

Facts On File, Inc.
11 Penn Plaza
New York, NY 10001

**Library of Congress Cataloging-in-Publication Data**

Stefoff, Rebecca, 1951–
   Women pioneers / Rebecca Stefoff.
      p.  cm. — (American Profiles)
   Includes bibliographical references and index.
   ISBN (invalid) 0-8160-3134-7 (alk. paper)
   1. Women pioneers—West (U.S.)—Biography—Juvenile lit-
erature.
   2. West (U.S.)—Biography—Juvenile literature. [1. Pioneers.
   2. Women—Biography.  3. Frontier and Pioneer life—West
(U.S.)  4. West (U.S.)—Biography.] I. Title.  Title.  II. Series: American
profiles (Facts On File, Inc.)
   F596.S828   1995
   920.7′0978′09034151dc20
   [B]                                                    95-13552

Facts On File books are available at special discounts when purchased in bulk quantities for businesses, associations, institutions, or sales promotions. Please call our Special Sales Department in New York at 212/967-8800 or 800/322-8755.

Cover design by F.C. Pusterla Design
Map design by Dale Williams

This book is printed on acid-free paper

Printed in the United States of America

VB FOF 10 9 8 7 6 5 4 3 2 1

# Contents

# TRAILS AND SETTLEMENTS OF THE AMERICAN WEST

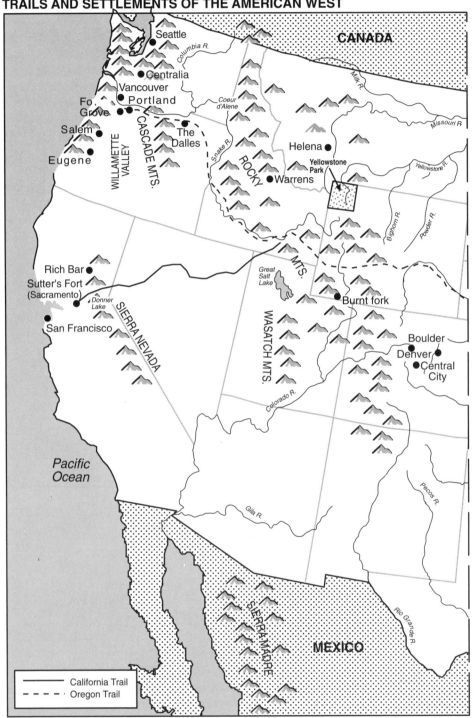

Current state boundaries are provided for reference.

# Acknowledgments

*T*he author is grateful to the following people and institutions for their help in the preparation of this book: Ruth Stewart and the estate of Elinore Pruitt Stewart; Lois Barton and the Spencer Butte Publishing Company, Eugene, Oregon; Rick Read, archivist of Pacific University, Forest Grove, Oregon, and curator of the University Museum; the staff of the Library and Photo Archives of the Oregon Historical Society, Portland; the Colorado Historical Society, Denver; the Denver Public Library, Western History Department, Denver, Colorado; the Idaho State Historical Society, Boise; the Montana Historical Society, Helena; and especially Zachary Harris.

## NOTE ON PHOTOS

Many of the illustrations and photographs used in this book are old, historical images. The quality of the prints is not always up to modern standards, as in many cases the originals are from old negatives or are damaged. The content of the illustrations, however, made their inclusion important despite problems in reproduction.

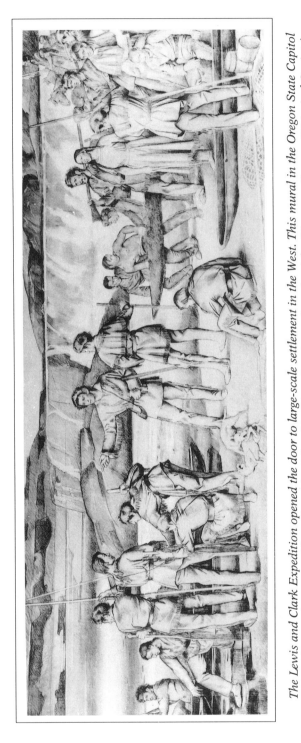

*The Lewis and Clark Expedition opened the door to large-scale settlement in the West. This mural in the Oregon State Capitol shows the expedition at Celilo Falls on the Columbia River; Sacajawea is at the right. (Courtesy Oregon Historical Society)*

# Introduction
# The West and the Women

*E*uropean colonists approached North America from two directions. The Spanish, moving north from their colony in Mexico, pushed into the Southwest from southern California to Texas, while the British colonized the East Coast, the region that later became the nucleus of the United States. Spanish and British methods of colonization were very different, however. The Spanish established trading posts, missions, and military forts to deal with the Native American peoples, but they had comparatively few private landholdings; there was no huge rush of settlers from Spain to stake out claims in the Southwest. But the eastern seaboard was settled by colonists from Great Britain and Europe who were eager to possess their own land. As the coastal colonies filled with settlers, they pushed the frontier of settlement ever westward.

It took 200 years—from the founding of the Jamestown colony in 1607 to about 1800—for the frontier to reach the Mississippi River, less than halfway across the continent. And then, in a single century, Americans settled the vast expanse of the West. That westward expansion, many historians have claimed, was the central American experience of the nineteenth century.

The opening of the West began in 1804–06 with the Lewis and Clark Expedition, which pioneered an overland route from the Mississippi to the Pacific coast of Oregon. This coast, which had been explored by mariners of many nations, was less mysterious than the unknown interior of the continent—and, with its fertile soil and mild climate, it was attractive to settlers. For these reasons, the western coast was settled before the Rocky Mountains or the Great Plains; the frontier of settlement leapfrogged from the Mississippi Valley to Oregon and California.

Within a few decades of the Lewis and Clark Expedition, emigrants from the eastern states were following several major overland trails across the West. The most important of these was the

Oregon Trail, which ran from Independence, Missouri, to Oregon's Willamette Valley, with a branch heading south into California. The Santa Fe Trail led into the Southwest.

Along these emigrant roads came thousands of families, hauling their possessions westward in canvas-topped wagons pulled by ox teams. The emigrants generally organized themselves into large wagon trains for protection from Indians and other hazards of the trail. Rolling across the plains, inching up and down treacherous mountain passes, the white-topped wagons were like sailing ships carrying their passengers to a distant shore. In places their tracks can still be seen, deep ruts carved into the land by hundreds of heavy iron-rimmed wooden wheels. By the end of the century, half a million men, women, and children had crossed the West on the emigrant trails.

Americans of the mid-nineteenth century were filled with confidence in themselves and their way of life. They believed that they should occupy the entire continent, from sea to sea—even though part of it was claimed by Mexico, and much of it was inhabited by Native Americans. In 1845 a newspaper editor declared that it was the "manifest destiny" of the United States to expand its frontiers all the way to the Pacific. "Manifest destiny" (meaning "clear purpose" or "clear fate" became the rallying cry of those Americans who wanted to seize Mexico's territory in Texas, California, and the Southwest. The United States annexed Texas in 1845 and went to war with Mexico the following year. When the war ended in 1848, the United States had wrested from Mexico all of its territory north of the Rio Grande.

That same year, gold was discovered at Sutter's Mill in California's Sacramento Valley, and America's first big gold rush began. Thousands of hopeful emigrants poured into California in 1849. Many left poorer than when they'd arrived, but many stayed, stimulating California's growth. Lesser gold rushes in Colorado, Montana, and South Dakota spurred settlement in these areas from the 1850s through the 1870s.

The Great Plains—Kansas, Nebraska, the Dakotas, and the grassy foothills of Wyoming and Montana—were the last part of the West to be extensively settled. To encourage settlement on the Plains, the U.S. Congress in 1862 passed the Homestead Act, under which any man over 21 years of age, or any head of a family, could acquire 160 acres of public land for free if the land was occupied and cultivated for five years. The act was intended to aid poor farmers, but few such farmers could afford the steel plows

and other machinery needed to farm successfully on the dry Plains, where in order to produce a decent crop a farmer had to cultivate five times as much land as did an eastern farmer. Land speculators took advantage of the act to acquire large tracts of land by establishing false claims; later, when the pace of settlement had picked up, they sold the land for large profits. Despite such abuses, however, the Homestead Act eventually opened up the Plains to emigrants from the increasingly crowded Mississippi Valley and from Europe. Settlement began in earnest in the 1870s.

The settling of the West can be seen it was also the climax of a shameful chapter in American history. As white pioneers spread across the American landscape, the original inhabitants were killed or driven off their land. Many Native Americans died of diseases introduced by the whites; many more were killed in the Indian wars that flared along every new frontier. Early in the nineteenth century, Indians from the eastern part of the country were forcibly relocated to the West, and the government began forcing the western tribes onto reservations.

Not all Americans approved of the way the Native Americans were being treated. Helen Hunt Jackson's *A Century of Dishonor*, published in 1881, was a scathing criticism of U.S. policy toward the Indians. The great majority of pioneers, however, viewed the Indians as a dangerous nuisance. At best, they were to be kept out of trouble on reservations; at worst, exterminated. Understandably, many Native Americans strenuously resisted these fates. Throughout the West they fought doggedly to retain control of their traditional lands. But the last major Indian wars ended in the 1880s, when Sitting Bull's northern Plains Lakota (Sioux) and the Apache under Geronimo were defeated. Although there were some defiant outbursts in later years, the Indian resistance had been broken.

Perhaps the most amazing thing about the taming of the American West was how quickly it happened. The first transcontinental railroad was completed in 1869, less than 70 years from the first crossing of the continent. By that time Texas, Wisconsin, California, Minnesota, Oregon, Kansas, Nevada, and Nebraska had become states; Colorado, Washington, North and South Dakota, Montana, Wyoming, Idaho, and Utah would follow before the end of the nineteenth century. In 1890, the director of the U.S. Census declared that the American frontier—the boundary between settled and unsettled land—had ceased to exist. More than a century later, however, the history of that frontier continues to be told and

retold, and new ways of looking at the pioneer experience continue to emerge.

The settling of the American frontier is more than a historical event. It has become a source of legends and myths, of symbols and images that help to define America. Most of the legendary or symbolic figures are men: the hardy mountain men, fur traders who pioneered routes through the Rocky Mountains; grizzled prospectors and gold miners; Indians and Indian fighters; cowboys, ranchers, and homesteaders. The role of women pioneers has often been overlooked. Yet women were part of the westward expansion from its very beginning. A Native American woman, Sacajawea of the Shoshone people, was a member of the Lewis and Clark Expedition.

Women went west, often in company with their husbands and fathers, but sometimes on their own. Most of the miners, loggers, ranchers, and Indian fighters were men, but it was women who cared for the sick, who founded churches and schools, and who

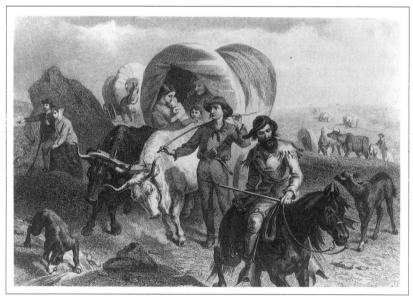

*A nineteenth-century illustration called* Emigrants Crossing the Plains
*captures the struggle to haul wagons and livestock over rough terrain—as*
*well as the quiet, patient endurance of the women and children who*
*made the journey.*
(Courtesy Oregon Historical Society)

turned crude camps into communities. Women pioneers were equal partners with men in the taming of the frontier.

The pioneer women recorded their experiences in diaries and in letters back to friends and family members in "the States." These tell a very different story from the history recorded by men. For the most part, men's accounts of the westward migration and of pioneer life are concerned with the practical details of emigration and settlement: the equipment and supplies needed for the overland journey, the distances covered each day, the availability of water and grass along the trail, hoto deal with the Indians, how to stake a claim and make a living on the new land, and the political organization of newly settled regions. The women recorded their emotional lives. They wrote of their grief at parting from loved ones back home. They told how they cried when they had to abandon a cherished chest of drawers, the last reminder of their former home, on the prairie because the wagon had become too heavy for the famished oxen to pull. They described everyday life on the trail, from the difficulties of cooking and keeping clean to the surprise they felt upon seeing their first Indian or buffalo. Women's accounts often included small, human details: what a pioneer girl wore to her wedding on the Oregon Trail, how to trade needles to Native American women for corn and venison, the epitaph on a baby's grave marker.

Recent years have seen a surge of interest in the women of the American frontier. Historians have uncovered letters and diaries that have lain unregarded in attics or archives for years, and historical societies have diligently preserved and published these priceless documents. Thanks to their efforts, many of the women pioneers can speak to us in their own voices, telling the stories of their hardships and triumphs.

# Further Reading

Butruille, Susan G. *Women's Voices from the Oregon Trail*. Boise, Idaho: Tamarack Books, 1993. An easy-to-read account of the Oregon Trail crossing; includes poems, quotes, and excerpts from letters and diaries by many women; contains a detailed guide to historic sites along the trail.

Drago, Harry. *Notorious Ladies of the Frontier*. New York: Dodd, Mead, 1969. Profiles of some colorful frontier women, including outlaws and dance-hall girls.

Faragher, John M. *Women and Men on the Overland Trail*. New Haven, Conn.: Yale University Press, 1979. A scholarly study; may be too difficult for younger readers.

Holmes, Kenneth L. *Covered Wagon Women*. 11 volumes. Glendale, Cal.: A.H. Clark Co., 1983–93. Profiles of hundreds of pioneer women; good source for research.

Jeffrey, Julie Roy. *Frontier Women*. New York: Hill and Wang, 1979. A summary of women's roles on the frontier; most young adults will find it readable.

Luchetti, Cathy and Carol Olwell. *Women of the West*. New York: Orion Books, 1982. A beautifully illustrated volume that contains a useful introduction, a thorough chapter on the history of minority women in the West, and profiles of eleven women, told in their own words. An excellent resource for young adults who are good readers.

Schlissel, Lillian. *Women's Diaries of the Westward Journey*. 2nd edition. New York: Schocken Books, 1992. A well-researched survey of the pioneer migration as experienced by women and children, with many quotes from women's letters and diaries.

Stratton, Joanna L. *Pioneer Women: Voices from the Kansas Frontier*. New York: Simon & Schuster, 1981. A history of women's lives in early Kansas, pieced together from hundreds of pioneer stories, including those of some immigrant women; dense but rewarding reading.

Swallow, Joan R. *The Women*. (The Old West Series.) Alexandria, Va.: Time-Life Books, 1978. A well-illustrated, highly readable account of women's lives in the Old West; excellent for younger readers.

Wexler, Sanford. *Westward Expansion: An Eyewitness History*. New York: Facts On File, 1991. An overview of frontier history from colonial times to the end of the nineteenth century; illustrated; includes useful chronologies and hundreds of quotes from the people who made and lived western history.

Wilson, Nancy Ross. *Westward the Women*. New York: Knopf, 1944. Reissued 1985. One of the first books to devote serious attention to women's history in the West; somewhat dated but still very readable.

# Rebecca Burlend
# Hard Times in the New World
# (1793–1872)

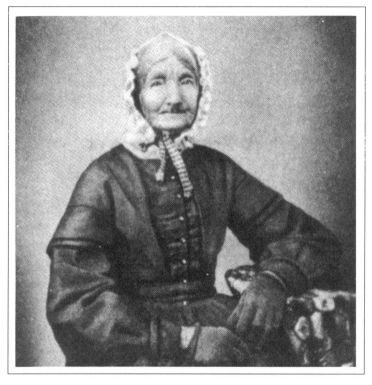

*Born and raised in the English countryside, Rebecca Burlend discovered that the American frontier was not the paradise of milk and honey that had been promised, yet she survived its hardships to reach a contented old age.*
(Courtesy Oregon Historical Society)

*T*he English began settling North America in the seventeenth century. For generations, English men and women came to the New World in search of religious freedom, a better life, or simply a new start. In the late eighteenth century, the American Revolution halted the flow of emigrants from England to North

1

America—but not for long. Two generations later, the English were once again turning to the wide-open American frontier in search of opportunities that they could not find in their tidy, long-domesticated homeland, where land had become so expensive that only the rich could own their own property.

Rebecca Burlend was one such emigrant. Leaving the familiar English landscape behind, she built a new life on the Illinois frontier, the edge of western settlement in the United States in the 1830s. But Burlend was an unwilling pioneer, drawn west not by curiosity or the spirit of adventure but by family ties. Like many pioneer women, she did not make the decision to settle on the frontier—her husband made it for her. She hated the thought of leaving England. "Whatever may have been our success in America," she later told one of her sons, "I can attribute little of it to myself; as I gave up the idea of ending my days in my own country with the utmost reluctance, and should never have become an emigrant, if obedience to my husband's wishes had left me any alternative." Yet Rebecca Burlend *did* deserve much of the credit for her family's success—and even for its very survival—in the New World.

Burlend was born Rebecca Burton on May 18, 1793, in the county of Yorkshire in northern England. Little is known of her background. Her parents were humble people, most likely farmers. Rebecca married John Burlend when she was in her late teens. Rebecca and John's oldest son, Edward, had established himself as a schoolteacher by 1831, when Rebecca was thirty-eight years old.

Large families were common then, and the Burlends had fourteen children in all. Tragically, childhood deaths were also common in the age before modern sanitation and medicine; four of the children died young. John and Rebecca Burlend raised their family in Yorkshire, never venturing more than 40 miles from their home until they began the great journey that took them across the Atlantic Ocean.

The Burlends were farmers, but like many of the poorer families in England, they could not afford to buy a farm. Beginning in 1817, they rented a Yorkshire farm for 14 years. Despite hard work, though, the Burlends could never seem to get ahead. Sometimes they could barely pay their bills and put food on the table.

# Rebecca Burlend

Paying rent was a "severe struggle," Rebecca Burlend said. Slowly the Burlends' small savings were eaten away and they slipped into debt. At the same time, the family kept growing, and John and Rebecca worried about the lack of prospects for their children. John Burlend began thinking about emigrating to "the western world."

A few years earlier, a Yorkshire man named Charles Bickerdie had emigrated to America and settled in Pike County, Illinois. His letters home to his brother in England made the Illinois frontier sound like a grand place, where the good things of life were abundant and land was cheap. In 1831 John Burlend decided to risk the dangers and uncertainties of life on the frontier. He announced to Rebecca and the children that they were going to Illinois. The Burlends' two oldest children—the schoolteacher, Edward, and Mary, who had found work as a servant—decided to stay in England. Rebecca was deeply sorrowful at having to part from them, as well as from all of her friends, her church, and everything that she knew and loved. She was almost too busy to grieve, however, for she and John were taking five children under the age of nine to the New World, and there was much to prepare. Within a few months, the Burlends had sold their furniture, settled their debts, and said their goodbyes.

The first stage of their journey took them by coach and train to the port of Liverpool. They were so excited to be traveling that they did not think about what Rebecca called "the importance of the step we were taking." But when the Burlends reached Liverpool, they learned that their ship did not sail for a week. They settled into the dark, cramped rooms of a cheap boardinghouse and fell into melancholy. "A stranger would have thought us a most unusual family," said Rebecca, "as we sat in profound silence for an hour together, only now and then a sigh would escape." John and Rebecca cried, thinking of the children they had left behind and worrying about the perils of an ocean crossing and an unknown land.

As the day of departure approached, John Burlend lost his nerve. Suddenly he declared that they should forget the idea of emigrating and go home. But Rebecca reminded him of how long he had been planning the move—and of the fact that they had nothing to return to in Yorkshire. They decided to stick to their plan. On September 2, 1831, they went to Liverpool Harbor, where the masts of the assembled vessels seemed to Rebecca to be "an immense forest of ships crowded like forest trees onto the sea further than the eye

could reach." They boarded their ship, which was bound for New Orleans. Its name, Rebecca saw with a pang, was *Home*.

As the ship sailed away, Rebecca Burlend looked back, watching the coast of England disappear into the distance and straining her eyes to keep it in view as long as she could. "I shall never forget," she said years later, "how enviously I looked upon the vessels that were approaching the shores I was leaving."

The first few days of the crossing were uneventful. People traveling in the cheapest accommodations, like the Burlends, had to provide their own meals, and Rebecca had brought food and utensils to cook for her family. Their shipboard diet was much like that of the pioneers who crossed the Great Plains in wagon trains: oatmeal, bacon, biscuits, tea, and coffee—all hardy, non-perishable items, but not very nourishing for weeks on end. It was hardly surprising that many of the seafarers and pioneers fell ill during their journeys.

A week or so into the voyage, the water grew rough and a storm blew up. "A thousand times I thought the ship would be upset by the force of the tempest," Rebecca said. "Every moment we expected the waters to rush in upon us. I shall never forget the horrors of that night, increased as they were by the heartrending moanings of my despairing companions." The seasick passengers huddled together and prayed for their deliverance. After the storm calmed, Rebecca watched the moon rising over the sea. The ship seemed terribly small and frail alone in "a world of water."

The *Home* had a scare as the West Indies approached. Another ship appeared, following the *Home* ever more closely. The passengers whispered fearfully about pirates, and the crew grimly cleaned and loaded the ship's guns. But the pursuing ship proved to be only another British passenger vessel, and the alarm ended. Then, as the Virgin Islands came into view, the passengers rushed to the deck to feast their eyes on "the luxuriant and beautiful appearance of the numerous little islands we were continually passing," as Rebecca Burlend said. She thought the islands were exceptionally lovely, but she admitted that might have been only because she missed land so much. At her first sight of the American mainland, Rebecca felt "a sort of melancholy" creeping over her. She later wondered whether the sadness had been a warning of the many hardships she was to endure in her new home.

The *Home* docked in New Orleans on November 1, a Sunday. Rebecca was shocked to see busy shops and crowded streets—this

was not how people spent Sunday back home in Yorkshire. She was also horrified by her first look at slavery: "I observed several groups of slaves linked together in chains, and driven about the streets like oxen under the yoke."

As uncomfortable as the *Home* had been, Rebecca Burlend was sorry to leave it. As she explained, "On leaving the ship I felt a renewal of my home-sickness, to use a quaint expression; it seemed to be the only remaining link between me and England. I was now going to be an alien among strangers."

The next stage of the Burlends' journey was a 12-day, 1,300-mile steamboat ride up the Mississippi River to St. Louis. Rebecca and her children spent hours gazing at the passing riverbanks as the boat slowly churned upstream. America, thought Rebecca, was hot, fertile, and flat. It had only one drawback: "These beautiful plantations are cultivated by slaves." Gradually the plantations gave way to "majestic forest trees and untrodden wilds," and Rebecca realized with a sinking feeling that her future home would probably look much like this wilderness.

The river voyage was uneventful but for one near-disaster. A man entered the Burlends' cabin one night to rob them. John Burlend drove the intruder away, but Rebecca was shaken by how close they had come to tragedy. Alone in a strange country without funds, the Burlends would have been in "a most miserable situation."

From St. Louis, following the instructions in Bickerdie's letters, they traveled 120 miles up the Illinois River to a place called Phillips' Ferry. Rebecca was weary to her very bones. "We had already travelled nearly seven thousand miles," she said. "Our food had been principally dried provisions. For many long weeks we had been oppressed with anxious suspense; there is therefore no cause for wonder, that, jaded and worn out as we were, we felt anxious to be at our destined situation." She kept asking the boat crew, "How much farther?" until the sailors' patience was almost exhausted.

Phillips' Ferry, when they reached it, was the first of many unpleasant surprises. They had expected a settlement of some sort, but there was "no landing place, no luggage yard, nor even a building of any kind within sight." The Burlends stood by the brink of the river, bordered by a dark wood, with no one near and no lights in sight. Night was falling. John and Rebecca looked at each other and burst into tears; then the children began crying. Recalled Rebecca later, "Is this America, thought

I, is this the reception I meet with after my long, painfully anxious and bereaving voyage?" She could not believe that she had given up her home only to find herself in a dark, deserted wilderness: "Above me was the chill blue canopy of heaven, a wide river before me, and a dark wood behind."

But they could not crouch on the riverbank all night. At last John ventured into the forest in search of help. Rebecca led the children in prayer. John discovered that the region was not as deserted as it had first appeared. He found a cattle track that led to the homestead of a family called Phillips. The Phillipses took the Burlends in for a few days, and Rebecca saw her first log house. It consisted of two rooms, separated by a partition of boards with many cracks; a cellar; walls of logs filled in with clay; a stone fireplace at one end; and a roof and floor made of oak shingles. The furniture was crude: a wooden table and bench, a few chairs and stools, and several plank beds. The only decorations were the hoes, axes, and rifles standing in a corner, some herbs and hams hanging from the ceiling, and a hand-loom on which Mrs. Phillips wove the family's clothes. Rebecca thought wistfully of the snug, neat cottages of England. She received a shock when Mrs. Phillips lit a pipe and calmly began smoking. It was unheard of for women to smoke in England. Mrs. Phillips assured her that tobacco use was common among American women. Rebecca realized that she had truly entered a strange new world.

A few days later, Mr. Phillips led the Burlends farther into the forest to Bickerdie's house. Bickerdie's cabin was even more primitive than the Phillips' home, and Rebecca was taken aback by his ragged clothes. The scruffy appearance of Bickerdie and his homestead did not match the picture he had painted in his letters of America as a land "flowing with milk and honey." Rebecca remarked tartly that he must have gathered his honey from thorns, not flowers.

Whatever their misgivings, the Burlends were now committed to making a new home in this strange and difficult place. The first step was to obtain land. The availability of land was the main attraction of the frontier to settlers from overcrowded Great Britain and Europe. "In Illinois and other new states there is plenty left unsold," as Rebecca reported. For $100, the Burlends bought an 80-acre parcel of land with 400 sugar-maple trees on it. This government-surveyed parcel had already been settled by an earlier pioneer, who told the Burlends how to get sugar from the trees by piercing them in early March, draining the sap into

wooden troughs, and repeatedly boiling and straining the sap until hard, raw sugar remained. For an extra $60, this settler gave the Burlends his log cabin and also the troughs, kettles, and other tools needed to make sugar.

When John and Rebecca moved into the cabin, their family possessed only two beds, a few cooking utensils, and two boxes of clothes. Soon afterward their food ran out, leaving them in desperate straits. John managed to obtain some corn flour, milk, and a little dried venison, or deer meat. This was all the Burlends had to eat for weeks. Trying to make the best use of their dwindling savings, they bought a cow and calf, a horse, two pigs, and an iron skillet in which to bake bread in the fire—an oven used too much firewood. Like other settlers, the Burlends ate three identical meals each day. Most consisted of bread and butter, bacon, and coffee. Fresh meat was rare, and fresh vegetables could be had only during summer.

The Burlends fell victim to an ailment that afflicted many of the pioneers in their area. Called the "Illinois mange," it caused them to break out all over in itchy spots. Rebecca, who possessed some skill at curing people with herbal medicines, thought that the "mange" was probably caused by the change in water. It soon cleared up, but by then everyone was suffering dreadfully from colds, for the Illinois winter was far more severe than anything they had experienced in Yorkshire. The Burlends had to keep fires burning constantly just to keep from freezing. Because they kept the door shut for warmth, they lived in a constant cloud of smoke and ash from their fireplace.

Rebecca marveled at the cold. "The frosts are intensely keen," she said, "and a wide river is sometimes iced over in a single night, so as to be unnavigable. The nights in winter are at once inexpressibly cold, and poetically fine. The sky is almost invariably clear, and the stars shine with a brilliancy entirely unknown in the humid atmosphere of England." Despite the cold, she would stand in the doorway at night, admiring the stars and listening to the howling of the wolves.

Daily life was much more arduous than anything Rebecca had known before. Instead of drawing water from a well, she had to chop ice from the river and melt it. Clothes and bedding became worn, but Rebecca could not replace them—there were no stores nearby, and goods were very expensive. She ran out of soap, but Mrs. Phillips told her how to make a substitute from ashes and

pig fat. She also ran out of candles; the family had to burn lard to see at night. John Burlend, too, had to learn to do tasks he never had to perform in England. He split logs into rails and laid fences around the border of his land. He also made a table, stools, and a bench so that the family could eat without having to sit on the floor.

Not long after their arrival in Illinois, the Burlends had a taste of what Rebecca called "frontier justice." Far from the reach of the law, the strong sometimes preyed upon the weak, and people had to defend themselves by whatever means they could. A local bully fed his horses in the Burlends' fields and threatened to beat or stab John Burlend if he resisted. Fortunately, the bully soon left the neighborhood, and John escaped having to fight him. But the incident made John and Rebecca wonder whether they wanted any contact with their neighbors in this uncivilized, "villainous" place. So they remained quite isolated, working from dawn until dusk every day except Sunday, when they prayed and read the Bible.

Rebecca later admitted that both she and John bitterly regretted having left England. Life in America was much harder and more primitive than they had expected, and they missed the simple, everyday comforts of home. They had neither beer for John nor tea for Rebecca. Perhaps they could have bought a few things to make their lives easier, but they were almost out of money and they did not want to go into debt. The whole point of emigrating had been to make themselves independent and escape their debts.

John did manage to snare a few quail for dinner, and once he caught what he thought was a wild turkey. He was as proud of this feat as if he'd slain a monster, and the Burlends invited Bickerdie to dine with them. To their dismay, however, the "turkey" turned out to be a vulture, and its flesh was foul and inedible.

Finally the winter cold began to abate. The Burlends experienced their first American spring. Rebecca tended the family sugar industry, producing 300 pounds of sugar and a barrel of molasses. She traded this at the closest store for corn, coffee, hoes, and an axe. It was mid-March and time to till the land, but they had no plow. So Rebecca, John, and their 10-year-old son, John, used the hoes to till four acres by hand. It was brutal, back-breaking labor, amid much rain and "awful and terrific" thunderstorms. "Every moment the voice of the thunder acquires additional compass, never ceasing even for a moment," said Rebecca, describing the mighty storms of the American Midwest, "but before

one peal has well broken on the ear, it is drowned by another still more tremendous and loud. The lightning is even more overpowering than the thunder. One moment all is in obscurity, a second the heavens seem rent asunder, the bright blue lightning dancing in all directions with a frightful and deadly velocity; meanwhile the rain descends in torrents, threatening to sweep away the foundation of the dwelling." For a long time after her first thunderstorm, Rebecca was more afraid of storms than of anything else in this new land, even wolves.

During the summer, a new scourge descended upon the Burlends: mosquitoes. Clouds of the stinging insects drove them crazy. Rebecca lay awake for hours at night, desperately tired but unable to sleep because of the buzzing, biting pests that swarmed around her face. The children, to her relief, seemed better able to bear this unpleasant plague—they managed to fall asleep at night with their heads buried beneath their blankets. And although summer brought the mosquitoes, it also brought nature's bounty. Tired of meal after meal of dried food, the Burlend children feasted on walnuts, raspberries, strawberries, and grapes, all of which grew wild on their land.

As time went on, Rebecca Burlend began to see the beauty in what had at first seemed a hostile, alien environment. The spring wildflowers were glorious, more numerous than any blooms she had seen in England. The woods were magnificent in their stateliness and great age. "Every thing here bears the mark of ancient undisturbed repose," she said. "The golden age still appears, and when the woodman with his axe enters these territories for the first time, he cannot resist the impression that he is about to commit a trespass on the virgin loveliness of nature, that he is going to bring into captivity what has been free for centuries."

By the end of June, the Burlends' first harvest of wheat was ready to be harvested. They borrowed sickles from Bickerdie to harvest the crop, but John Burlend fell and cut his knee badly on one of the sickles. The wound grew swollen and infected; John was delirious with pain, and Rebecca expected him to die. "I could not but perceive I was likely to lose my dearest earthly friend, and with him all visible means of supporting myself, or maintaining my family," she recalled later. "I was almost driven to frenzy. Despair began to lay hold of me with his iron sinews; I longed to exchange situations with my husband; there was no one near to assist or encourage me." Never since leaving Yorkshire had she

felt so frightened or so alone. But John did not die. His leg grew better, although it was a long time until he could work. Rebecca and young John had to cut the grain, bring it in from the fields, and make haystacks, all by hand.

During the long, warm days of summer, Rebecca and her children explored their land and began to become familiar with the other creatures who inhabited it. Illinois, Rebecca discovered, was full of birds unknown back in England. She said, "Their tones possess every degree of hoarseness, chatter, and chirp, that can possibly be conceived." She missed the nightingales and other songbirds of England; to her, the uproar of American birds in the spring forest was noise, not music, but she admired its variety and vigor. She also noted a great number of snakes, especially the nonpoisonous black racer, the venomous copperhead, and the rattlesnake, which was often found among the cornstalks. Rebecca killed a number of snakes with her hoe while working in the fields, and once a neighbor was bitten on the heel by a rattler and nearly died; Rebecca cautioned the children to flee when they heard the deadly rattle.

Even the ants of America were unlike those of England. Rebecca was used to small, relatively harmless ants. But, as she discovered the hard way, some American ants were large, biting creatures. She reported that travelers unfamiliar with these insects sometimes sat down gratefully on large, inviting hills of sand, only to regret it later when they were attacked by the fierce inhabitants of these anthills.

Summer nights held still more surprises. Coming home one evening, John and Rebecca noticed "sparks of fire dancing about most mysteriously." Fearing that these tiny moving lights were of supernatural origin, the Burlends told a neighbor what they had seen—only to be told, with much laughter, about "lightning bugs."

Other aspects of the American wilderness seemed supernatural at first because the Burlends had no prior experience with which to compare them. One day John Burlend followed a set of tiny footprints across several fields because he thought they had been made by fairies or by a mysterious race of small, hidden Indians. To his amazement, he found that the delicate, human-looking prints had been made by a raccoon.

The Burlends sold their wheat harvest and bought shoes, a plow, tin milk bowls, and some coffee with the money. They had planned to buy new clothes, too, as their old ones were ragged, but they could not afford them. Unable to face the thought of plowing their

wheatfield again by hand, they gave John's watch to a neighbor in exchange for his promise to let them use his team of horses to plow their field.

The first anniversary of the Burlends' arrival in America fell on the same date as a yearly festival at their little Yorkshire village, and the day found them lost in thought of home. John and Rebecca missed their loved ones in England. Seeing their younger children in torn clothes facing another hard winter, they could not convince themselves that they had improved their lives by emigrating. To make matters worse, both John and Rebecca suffered from an illness that might have been either pneumonia or influenza.

During their second winter, the Burlends bought three cattle from a man named Van Dusen, promising to pay him $30 during the next year. Van Dusen tried to collect the $30 in March, before the Burlends had any crops to sell. When they told him that they did not yet have the money, he threatened to go to court and take their land as payment for the debt. Now John and Rebecca were deeply sorry that they had bought the cattle on credit. They went to Bickerdie for help, but he refused to lend them the money. Rebecca and her husband were plunged into despair. They had such good intentions, they had worked so hard, and now they might lose their land. They passed a terrible night in fear and crying, but in the morning, Bickerdie appeared and gave them the money, moved by his conscience. They repaid him as soon as they had harvested their crops.

Slowly but steadily, the Burlends' circumstances improved. They acquired pigs, a small herd of cattle, and a fine young mare. They cut and burned stumps, cleared more land, and made a large garden for potatoes and vegetables. Rebecca worked hard in the garden even though she was pregnant with twins, who were born during the Burlends' second year in America. Around this time the Burlend family began to feel more comfortable in the community. A neighbor helped them sow their corn crop, and, said Rebecca, "We therefore began to feel ourselves more composed, and to use a good old English phrase 'more at home.'" By the time they harvested their second wheat crop, they had enough money to buy some new clothing, as well as some salt and a harness for the plow.

In the Burlends' third year, things were going so well that John decided to buy the neighboring parcel of land. To protect their claim to the land, Rebecca moved there with the two youngest

children. They lived in a rude cabin half a mile away from the main family house. One night another settler showed up with his family, intending to run Rebecca off the land so that he could claim it. He kept her and the children prisoners for three days, insulting and threatening them. The interloper, joined by several of his friends, tried everything but physical assaults to drive Rebecca away, but she had acquired some of the toughness of the American frontier, and she refused to be bullied. Finally John Burlend arrived with reinforcements and frightened the intruders into leaving. Ironically, the Burlends later sold the land to this man—but at a handsome profit.

In her account of this episode, Rebecca Burlend explained that some Americans were sharp operators who were not above using trickery and deceit to get the advantage when competing for land. Many people, too, were ignorant of the law and therefore were easily bullied or fooled. Many of the pioneers could not read their own land grants. Illiteracy was widespread on the frontier, among both old and young. The government set aside land for schools in each new region it surveyed, but, according to Rebecca Burlend, some of the frontier teachers were poorly qualified, and some districts had no teacher at all. School was a hit or miss affair in the early days of frontier settlement.

So was religion. In England, Rebecca Burlend had belonged to the Methodist church. She heard that a Methodist prayer meeting was being held only two miles from Phillips' Ferry and was eager to attend, but she was startled by some of the worshippers' antics. They danced, shouted, and threw themselves into strange postures—not like the sedate churchgoers of England. Rebecca disapproved of the "camp meetings" and other enthusiastic practices of some rough-and-ready frontier preachers.

Despite their initial doubts, the Burlends did eventually build a better life for themselves in America than they probably would have had in England. Ten years after emigrating, they had built a new, comfortable house with proper furnishings. They had plenty of food, a herd of 20 cattle, and a total of 360 productive acres. Rebecca said that their success came from working together as a family, so that they did not have to hire laborers: "If our success has been ultimately greater than at one time we anticipated, or even than that of many of our neighbors, as indeed it had, it must be borne in mind that our industry and perseverance have been unremitting. If our cattle and lands have kept increasing, that

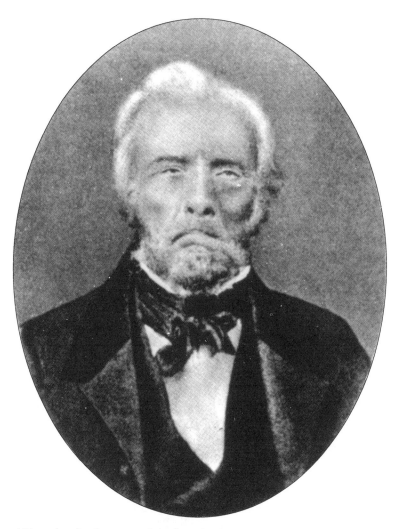

*Although schoolmaster Edward Burlend never left England, he wrote a popular book about his mother's pioneering adventures in Illinois. She wanted the book to give "a true picture" of frontier life to offset the rosy, unrealistic accounts of other emigrants.*
(Courtesy Oregon Historical Society)

increase is but the reward for the numberless anxieties we have undergone. Few would undertake the latter to secure the former."

Throughout her years in Illinois, Rebecca had kept in touch with her two adult children in England through frequent letters. In 1846, Charles Bickerdie died and his brother came from England to settle his estate. Longing to visit her children, Rebecca decided to travel back to England with the brother when he returned, even though she hated the thought of making two more ocean crossings and leaving her younger children motherless for months. Having arrived safely in England, she joyously revisited the places of her youth. She told the story of her life in America to her son Edward, who wrote it up as a short book called *A True Picture of Emigration*. The book was published in England and sold thousands of copies. Rebecca explained that the book's purpose was to present the truth about life in the American West—not a falsely rosy picture, like the one Bickerdie had painted, but a picture showing the hazards and sorrows of emigration as well as its rewards. She figured that her story would either attract people to the idea of emigration or make them content with a humble cottage in the land of their birth.

Rebecca returned to Illinois after only three months back in England. Several Yorkshire families who had read her book soon came to Pike County and settled near the Burlends. Among them were John and Rebecca Burlend's daughter Mary and her husband and children. At the end of their lives, John and Rebecca lived with Mary and her family. Rebecca's grandson later remembered how his grandmother spent her evenings sitting by the fire, gazing into the flickering lights—and smoking a pipe.

John Burlend died a respected member of the community in 1871 at the age of 88, and Rebecca followed him on January 31, 1872, 40 years after she came to Illinois. The frontier had moved west long before her death, but Rebecca Burlend never forgot the struggle, loneliness, and sacrifice she had undergone as a pioneer wife and mother. She was one of many thousands of women whose patient, resourceful work, and endurance helped to tame the American frontier.

# Chronology

| | |
|---|---|
| **May 18, 1793** | Rebecca Burton is born in Yorkshire, England |
| **c. 1810** | marries John Burlend |
| **1810–1820s** | gives birth to children |
| **1817** | Burlends rent farm in Yorkshire |
| **1831** | emigrates to United States with husband and children |
| **1831** | Burlends buy 80 acres for $100 |
| **c. 1832–33** | Rebecca Burlend gives birth to twins |
| **c. 1841** | Burlends build a new house |
| **1846** | visits former home in England; tells story to son Edward |
| **1848** | *A True Picture of Emigration* is published in England |
| **1871** | John Burlend dies |
| **January 31, 1872** | Rebecca Burlend dies in Illinois |

# Further Reading

Burlend, Rebecca and Edward Burlend. *A True Picture of Emigration*. Milo Milton, Quaife, editor. Lincoln: University of Nebraska Press, 1987. Highly readable but not very easy to find; a reprint of an edition of Edward Burlend's book that was published in 1936 (this material was originally published in England in 1848).

# Virginia Reed
# "You Don't Know What Trouble Is"

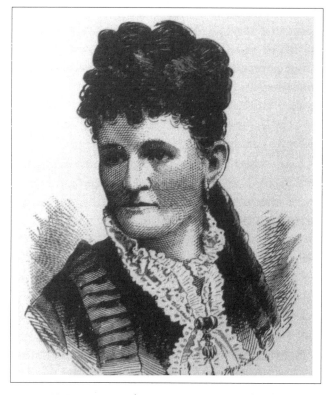

*At 12, Virginia Reed set out on a journey that led to starvation, cold, and misery. She survived to become a successful California businesswoman, but she never forgot the suffering she had endured. Her advice to other emigrants: "never take no cutofs and hurry along as fast as you can."*
(From *Century Magazine*; photo by C/Z HARRIS)

---

*O*n April 16, 1846 three families set out from Springfield, Illinois, on the first leg of their trek to California. One family consisted of George Donner, his wife, Tamsen, and their children. His older brother Jacob was accompanied by his wife, Elizabeth, and their

children. The organizer of the expedition was 46-year-old James Frazier Reed. A wealthy furniture manufacturer, Reed believed that he could do even better in California than he had in Illinois. With him were his wife, Margaret, and their three children: Martha, age eight, who was called Patty; James, Jr., age five, and Thomas, age three. Also present was Virginia Backenstoe, Margaret's 12-year-old daughter by an earlier marriage. James Reed had married Virginia's mother when Virginia was very young, and he loved the girl as though she were his own daughter. She was usually called Virginia Reed. Margaret Reed's mother, Sarah Keyes, had insisted on making the trip as well. She was elderly and sick, yet she could not bear the thought of being parted from her daughter and grandchildren.

The Reeds, as befitted their wealth and status, were traveling west in style. Sarah, Margaret, and the children would ride in an enormous two-story wagon equipped with an iron stove, padded seats, and sleeping bunks. Virginia had dubbed this impressive vehicle the "pioneer palace car," and on the day of departure the people of Springfield marveled at it.

The emigrants received an emotional send-off. "My father with tears in his eyes tried to smile as one friend after another grasped his hand in a last farewell," Virginia recalled later. "Mama was overcome with grief. At last we were all in the wagons, the drivers cracked their whips, the oxen moved slowly forward, and the long journey had begun." Virginia's schoolmates had also come to kiss her goodbye. As she waved excitedly to them from the wagon on that spring day, Virginia did not know that before the year was out she would share one of the most notorious adventures of the Old West, an adventure filled with desperation, bloodshed, and horror—and also with heroism and endurance.

In Independence, Missouri, the Donners and the Reeds joined a large wagon train bound for California. Thousands of emigrants were headed west in 1846, many of them inspired by a book that had been published the previous year, *The Emigrant's Guide to Oregon and California*. The author was an ambitious adventurer named Lansford W. Hastings, who hoped to found an independent republic in California. To encourage settlers to come to California, he had not only sung the virtues of its climate and the land's fertility but had also described a new route that, he claimed, would make the 2,500-mile journey shorter and easier. Hastings had never actually seen this so-called short-cut; he had only heard

rumors about it. But the hopeful emigrants who followed his directions did not know this.

All went well at first. "Our wagon was so comfortable," said Virginia, "that mama could sit reading and chatting with the little ones and almost forget that she was really crossing the plains." Virginia sometimes sat in the wagon and sometimes rode her own pony. The trip seemed pleasant and carefree, marred only by the quiet death of Sarah Keyes in Kansas. Virginia wrote about her grandmother's death in a letter that was carried back to Illinois by a returning rider: "We buried her verry decent. . . . We miss her verry much every time we come into the Wagon we look at the bed for her."

By June the wagon train had reached the Platte River. Wrote Tamsen Donner, "I never could have believed we could have traveled so far with so little difficulty. Indeed, if I do not experience something far worse than I have yet done, I shall say the trouble is all in getting started." Tamsen Donner did not know it, of course, but all her troubles lay ahead.

At Fort Laramie, Reed was warned that the short-cut he planned to take, the "Hastings Cut-off," south of the Great Salt Lake was impassable for heavy wagons. Yet Reed insisted that he would travel by the shortest route. That insistence was to prove fatal for some of his fellow emigrants. In mid-July the wagon train camped along the Little Sandy River in what is now western Wyoming. They had come a thousand miles from Independence, but they had more than a thousand still to go. Most of the emigrants in the wagon train decided to continue along the better-known main route of the Oregon Trail, north of the Great Salt Lake. But twenty wagons veered south toward the Hastings Cut-off. Among them were the nine wagons of the Donners and the Reeds. The emigrants of this splinter group elected George Donner their leader, and as a result they have gone into history as the Donner Party.

The Donner Party emigrants had expected to find Lansford Hastings himself waiting along the way to lead them to California, but they missed him by several weeks. He had already set out to guide an earlier party through his cut-off, but he had left instructions for those who followed. As they rolled ahead along the tracks Hastings had left, the members of the Donner Party realized that they had no time to waste. It was already past mid-summer. If they were to reach the Sacramento Valley in California before their supplies gave out, they had to cover hundreds of miles of unknown

terrain and cross the towering ramparts of the Sierra Nevada range before the winter snows closed the Sierra passes.

The emigrants worked their way into the rugged mountains and canyons of Utah. In early August they found a note from Hastings, warning that the trail ahead was very bad. James Reed raced ahead for five days and caught up with Hastings, who refused to come back to help the Donner Party but suggested an alternate route that might be easier. Reed returned to the Donner Party to guide the wagons through the route that Hastings had pointed out from a hilltop. Unfortunately, this route led them down Echo Canyon and into the Wasatch Mountains, across some of the most rugged terrain in the West. Progress was agonizingly slow. The emigrants had to chop a road through thick underbrush up the steepest slopes they had yet seen, and then lower their wagons with the greatest care down the steep inclines on the other side.

"Worn with travel and greatly discouraged," Virginia wrote later, "we reached the shore of the Great Salt Lake. It had taken an entire month instead of a week." The land in front of them was far from welcoming. Said Virginia, "It was a dreary, desolate, alkali waste; not a living thing was to be seen; it seemed as though the hand of death had been laid upon the country." And it was now the end of August. They would have to hurry to make it across the Sierra Nevada. Yet one of the worst parts of the journey lay still ahead: the Great Salt Lake Desert.

Hastings had told them that it would take them two days and two nights to cross the desert. It took five, and their water ran out after two days. Suffering horribly from thirst, the emigrants pressed ahead. Many had hallucinations, imagining that they saw lakes and waterfalls in the middle of the glistening salt desert. The party's unity collapsed under the strain. Those who could make faster progress abandoned the slower travelers, and some families refused to share their remaining water with those who had none. Mothers gave their children bullets to suck, hoping this would produce a little saliva to moisten the parched throats.

Everyone survived the desert crossing, but the Reeds suffered a serious disaster. Their oxen bolted, and the family had to abandon the palatial wagon. Many other wagons had to be left behind when the oxen that pulled them died or ran off. To make matters worse, the hilltops were already fringed with the first snows. It was clear that the Donner Party's supplies were insufficient to get them through to the Sacramento Valley. Two of the men volunteered to

ride ahead to California and bring back aid. The rest pushed on—they had no choice. In early October they rejoined the main emigrant trail along the Humboldt River in present-day Nevada. All of the other wagon trains of the season, however, had long since passed westward. The Hastings Cut-off was not only rougher than the main route, but, as the Donner Party had found to their dismay, 150 miles longer as well.

By this time, the members of the Donner Party were nervous, afraid, and exhausted. Tempers were short. On October 5, an argument broke out between James Reed and another emigrant named John Snyder. Snyder struck Reed with an ox-whip, and Reed pulled a knife and stabbed Snyder. The blow was fatal; Snyder died a few moments later. Horrified by what he had done, Reed hurled his knife into the river. Virginia had to dress Reed's bloody head wound, for her mother was too hysterical to do it. The emigrants held a council to decide on Reed's punishment. Reed's wealth and his aristocratic manners had made him unpopular with some of the emigrants; in addition, many held him responsible for the long delay in the Wasatch Mountains. Some wanted to hang him on the spot. Virginia and the other children huddled in terror in Margaret Reed's skirts as an emigrant named Keseberg raised his wagon tongue, the long timber to which to oxen were harnessed, to serve as a gallows. In the end, however, Reed was banished from the group. Parting from his family with tears and lamentations, he rode ahead, promising to bring relief from California.

"We traveled on," Virginia recalled. "The hours dragged slowly along. Every day we searched for some sign of Papa, who would leave a letter by the wayside. But a time came when we found no letter, and no trace of him." The Reeds lost more oxen; Margaret Reed had to abandon her remaining wagons and cache most of the family's possessions along the way, hoping against hope that one day she would be able to come back and reclaim them. She was forced to depend upon the kindness of her friends among the emigrants, who took turns carrying her and the children in their wagons. Often all but the youngest children had to walk for hours at a time.

Morale was disintegrating. When Keseberg turned an elderly German emigrant named Wolfinger out of his wagon after a quarrel, none of the others would take him in. Wolfinger was left behind in the wilderness, where he died. More oxen were lost, this time to the poisoned arrows of Paiute Indians. The emigrants

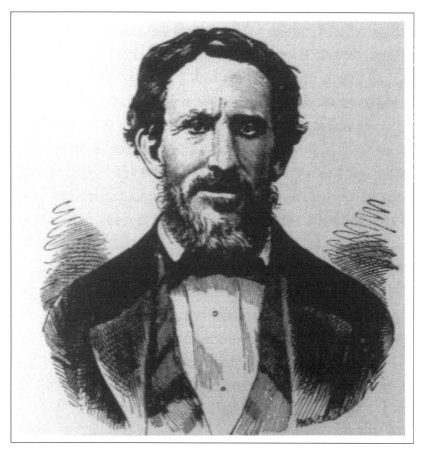

*Temperamental, aristocratic James Reed was unpopular with many of his fellow emigrants. Hoping to lead his family to a prosperous new life in California, he was banished from the wagon train and separated from his wife and children throughout their ordeal in the Sierra Nevada.*
(From *Century Magazine*; photo by C/Z HARRIS)

could hear the Indians laughing at them from atop the surrounding hills.

On October 20, with its supply of food almost completely exhausted, the Donner Party reached a region called the Truckee Meadows, near the present-day site of Reno, Nevada.

# Virginia Reed

There one of the men who had ridden ahead to California reappeared, bringing two Indian guides and seven pack mules loaded with supplies. Heartened, the emigrants decided to rest their weary oxen for five days before crossing the summit of the Sierra Nevada, only 50 miles away. This delay proved disastrous. On the day they finally attempted the summit, a snowstorm dropped five feet of snow. "Despair drove many nearly frantic," Virginia said. "The farther we went up, the deeper the snow got. The wagons could not go." Defeated, the emigrants of the Donner Party turned back to the shore of Truckee Lake (now called Donner Lake) on November 3. They built cabins and prepared to wait until the spring thaw, even though they knew that their supplies would never last through the winter. Eighty-one people—25 men, 15 women, and 41 children—were crammed into five makeshift shelters in two dismal camps. Margaret Reed and her four children shared a small log cabin with the 12 members of the Graves family.

Meanwhile, James Reed had reached Sutter's Fort in the Sacramento Valley in late October, just ahead of the winter snows. He made one desperate attempt to go back over the pass to rescue his family but was forced to turn back by a heavy snowfall. Then he went south to the San Francisco Bay to organize a relief mission. Moved by the plight of emigrants stranded on the far side of the pass, Californians contributed a substantial sum of cash for a relief effort to be headed by an army officer named Woodworth. But the Mexican War delayed the relief effort, which could not get under way until February of 1847. By that time the Donner Party had already entered the worst stage of its fate.

The hardier emigrants made several attempts to escape over the pass on foot but had to turn back each time. In mid-December 17 of them, including five women and several of the older children, tried again, this time on snowshoes made from wood and oxhide. The snowshoers' ordeal was an epic in its own right. It took them a month to cross the pass and reach the first ranch on the other side. Along the way eight of the emigrant men died of cold and exhaustion; the others survived by eating the bodies of the dead. Horribly, the two Indian guides, who had accompanied the snowshoe party, were murdered by the emigrants for use as food.

Those who had remained at the lake soon ran out of flour, meat, and other provisions. They soaked oxhides in water and ate the

gluey hides, but some of them could not digest this crude fare. Soon people started to die—and some of those who remained alive resorted to cannibalism, eating the flesh of the dead. Virginia reported that the Reeds were the "onely family that did not eat human flesh," although the truth of this claim has been questioned. For part of the winter Virginia and the other Reed children lived in the cabin of the Breen family, who were known to have cooked and eaten meat from the corpses, and Virginia recalled that Peggy Breen used to give her bits of meat, although this happened when no one was looking because Patrick Breen begrudged sharing food with the Reeds. So impressed was Virginia with Patrick Breen's fervent prayers that she promised to become a Catholic if she ever made it to California alive.

In January Margaret Reed tried to walk across the pass with Virginia. They had to turn back, and Virginia's feet were badly frostbitten. Finally, in mid-February, the advance party of the relief mission made it through to the lake, bringing some supplies. They then guided the first group of refugees back over the pass. Among these were Margaret Reed, along with Virginia and James, Jr. The younger Reed children, too small to walk, had to be left at the camp. Virginia later recalled that leaving them there was the hardest thing that she had yet had to endure.

Virginia and Jimmy Reed walked all the way across the pass, through snow almost up to their armpits. Virginia encouraged Jimmy by telling him that every step took him closer to his father—and to something to eat. On the other side of the pass the refugees met James Reed, who was leading the second relief party. Margaret and her children greeted him with joy. "o Mary," wrote Virginia to a cousin a few months later, "you do not know how glad we was to see him." James Reed recorded in his diary the desperate condition of the refugees: "I can-not describe the death-like look they all had. Bread Bread Bread was the begging of every child and every grown person except my Wife."

Thanks to the remarkable exertions of the relief volunteers, the remaining survivors of the Donner Party were brought out of the lake camp during March and April. Of the 89 members of the party, 47 survived, although they lost all of their horses and oxen and almost all of their property. Historian George Stewart has called the Donner Party's disaster "the most spectacular in the record of western migration." In the wake of the disaster, rumors and accusations began to spread. Keseberg, who later opened a

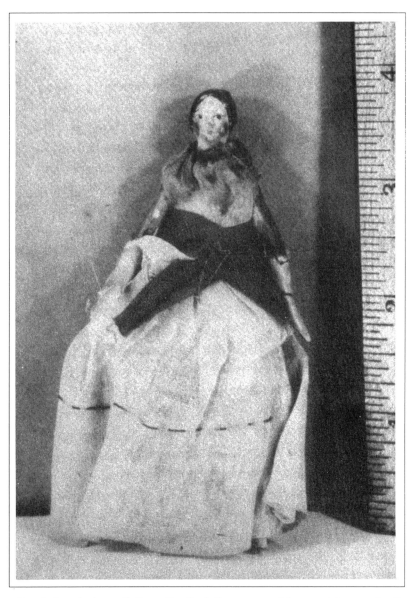

*Barely four inches tall, Patty Reed's doll was one of the surviving goods of the Donner Party's ordeal. Patty hid it in her clothes during the trek over the mountains, fearing that the adults would throw it away to lighten the load.*
(Photo by C/Z HARRIS)

restaurant, was said to have boasted of his fondness for human flesh; it was hinted that he may have murdered Tamsen Donner in order to eat her. There were also questions about gold belonging to the Donners, Reeds, and Graveses. Some accounts suggest that a few of the relief workers tried to rob or extort money from the refugees.

The complete truth about events at the Donner Lake camp will never be known. But Virginia Reed and her family emerged alive, and Virginia kept her promise and converted to Roman Catholicism. In April 1847, from the safety of the Sacramento Valley, she wrote to her cousin Mary in Illinois, "O Mary I have not rote you half of the truble we have had but I have rote you anuf to let you now that you dont now what truble is but thank god we have all got throw." The letter was published later that year in the *Illinois Journal* and it was the first detailed account of the Donner Party disaster to reach the East. Although the letter revealed that cannibalism had taken place, Virginia did not give many details.

Virginia thrived in California. In 1850, at the age of 17, she married an army officer named John M. Murphy. The Murphys later went into the real estate business. The latter years of the nineteenth century brought a revival of interest in the Donner Party, and in 1891 Virginia published an account of her experiences in *Century Magazine*. She lived on until 1921, one of the last survivors of an extraordinary journey.

# Chronology

| | |
|---|---|
| **1834** | Virginia Backenstoe born |
| **April 1846** | leaves Springfield, Illinois, with family for trip to California |
| **October 1849** | James Reed is banished from group |
| **November 1849** | party snowbound at Donner Lake |
| **February 1847** | first relief effort reaches lake |
| **April 1847** | last survivors brought away from lake |
| **December 1847** | Virginia's letter published in *Illinois Journal* |
| **1850** | Virginia marries John M. Murphy in California |
| **1861** | Margaret Reed dies |
| **1874** | James Reed dies |
| **1891** | Virginia publishes article about Donner Party in *Century Magazine* |
| **1921** | Virgina Murphy dies in California |

# Further Reading

Brown, Dee. *The Gentle Tamers: Women of the Old Wild West*. Lincoln: University of Nebraska Press, 1958. Readable and easy to locate in libraries; contains a short section on Virginia Reed.

McGlashan, C. F. *History of the Donner Party: A Tragedy of the Sierra*. 3rd edition. Stanford: Stanford University Press, 1947. Originally published 1881. The first book-length account of the Donner Party; flowery style makes it difficult reading today.

Murphy, Virginia Reed. "Across the Plains in the Donner Party (1846)." *Century Magazine*, July 1891. Hard to find; usually on microfilm.

Stewart, George. *Ordeal by Hunger: The Story of the Donner Party*. 2nd edition. Boston: Houghton Mifflin, 1960. Originally published 1936. The most complete book-length account of the Donner Party; very readable for all ages.

# Tabitha Brown
## Mother of Oregon
## (1780–1858)

*Led astray by a "rascally fellow," 67-year-old Tabitha Brown and her companions endured a grueling journey through the rugged mountains of southern Oregon.*
(Courtesy Pacific University Archives,
Forest Grove, Oregon)

*T*he western frontier was alluring to all sorts of people—to rich and poor, to men and women, and to the old as well as the young. Many of those who crossed the Plains were grandparents. Some wanted to try life on the frontier; others came because they did

not want to be parted from their children and grandchildren who were determined to go west. These elderly emigrants often proved tougher and more resilient than anyone expected. Tabitha Brown, who set out on the Oregon Trail at the age of 66, not only survived a particularly difficult crossing but became a figure of some importance in her new frontier home.

-------

Little is known about Tabitha Brown's early life. She was born Tabitha Moffatt in Brimfield, Massachusetts, on May 1, 1780. At the age of 19, she married the Reverend Clark Brown, a Congregational minister. They had four children: boys named Orus, Manthano, and John, and a girl named Pherne. John died as a child. The Reverend Clark died in 1817, leaving Tabitha penniless with three children. To support the family, she became a schoolteacher.

By the 1840s, when the great westward migration began, Tabitha Brown was living in Missouri, the gateway to the Oregon Trail. Her son Orus Brown made a trip to Oregon in 1843, "to look at the country," as Tabitha put it. Apparently he liked what he saw, for he went to Oregon again in 1845. On his way back, he and two companions were attacked by Pawnee Indians, who stole their supplies. Brown and the others managed to escape, however, and lived off the land until they made it safely to the frontier settlements. So enthusiastic was Orus Brown about the Oregon Territory that his entire family, with the exception of his brother Manthano, decided to go west in 1846, just five years after the first wagons rolled out along the Oregon Trail.

Like all pioneer emigrants, Tabitha Brown and her relatives prepared for the trip as carefully as they were able, knowing that the proper supplies and equipment might well save their lives during the journey. Orus Brown, with his wife and eight children, had one wagon. Tabitha's daughter, Pherne, with her husband, Virgil Pringle, and their five children had another. Tabitha, in a third wagon, was accompanied by her late husband's brother, a retired 74-year-old sea captain whom she called Captain Brown or Uncle John. She later wrote, "I provided for myself a good ox wagon team and a supply of what was requisite for the comfort of myself, Captain Brown and my driver."

# Tabitha Brown

The Oregon Territory—present-day Oregon, Washington, Idaho, and parts of Montana and Wyoming—became part of the United States in 1846, and that summer was an especially busy one on the trail leading West. One observer estimated that 7,000 wagons congregated in Independence, Missouri, in the spring of 1846, waiting to set out. The three wagons of Tabitha Brown's party were part of this throng. They joined a train of about 40 wagons and left Missouri in April "in high expectation of gaining the wished-for land of promise," as Tabitha said.

Tabitha Brown's account of the journey says little about the first five months of travel: "Our journey with little exception was pleasing and prosperous until after we passed Fort Hall [Idaho]," she wrote. But her son-in-law, Virgil Pringle, kept a diary in which he recorded the miles covered each day—sometimes only four, sometimes as many as twenty. His entries show that even a "pleasing and prosperous" overland trip could be full of incident and even of tragedy.

On May 5, one of the wagons overturned. "Mrs. B. badly hurt and one of the children slightly," wrote Pringle. "All much alarmed for Mrs. Brown." It is not clear whether the sufferer was Tabitha Brown or Orus Brown's wife. The party spent the next day in camp so that she could rest.

Ten days later they crossed the Kansas River on a ferry "which consists of two flat boats owned by a Shawnee Indian whose name is Fish." Pringle also reported that a number of the company were suffering from the bane of many a traveler—"a bowel complaint."

On May 31 the emigrants were drenched in rain "cold enough for November." They had traveled about 470 miles from their starting point, and the next day they saw the sandhills along the Platte River in present-day Nebraska. "This is the most romantic view I have ever seen," Pringle wrote. He also recorded the first death of the journey. A little girl died of scarlet fever and was buried along the side of the trail.

In mid-June, in western Nebraska, the wagon train passed Chimney Rock, a tall spire of rock that was one of the best-known landmarks along the Oregon Trail. Nearby they encountered a large camp of Lakota Indians and treated the Lakota leaders to a feast.

Many of Pringle's entries are concerned with the weather and with such considerations as the availability of water and grass for the oxen. His accounts of the human events of the trip are brief

and matter-of-fact. When he recorded on July 21, "This morning Mr. Thompson had a daughter born," he said nothing about the mother's health or the daughter's name, but added, "which detained us this day." He gave a bit more detail about a sad event that occurred on August 3: "Made an early start from the spring . . . but was stopped by an awful calamity. Mr. Collins's son George, about 6 years old, fell from the wagon and the wheels ran over his head, killing him instantly; the remainder of the day occupied in burying him." Such deaths were not uncommon on the Oregon Trail. Parents often found it impossible to keep an eye on every member of a large brood of active children, and a youngster who fell from a wagon was in real danger of being crushed. Weakened by the stresses of travel and sometimes by thirst or hunger, children also fell victim to disease. Nearly every wagon train left in its wake some small graves.

Tabitha Brown's problems started in the vicinity of Fort Hall in southern Idaho. Orus Brown had been chosen as one of the leaders of the wagon train. His wagon was about six days ahead of Tabitha's and Virgil Pringle's, and he was not at hand to give advice about the route onward from Fort Hall. The Oregon Trail ran northwest to the Columbia River, which today marks the border between the states of Oregon and Washington. The trail followed the river to the Willamette Valley in western Oregon, the settlers' goal. Tabitha and Virgil Brown were "within eight hundred miles of Oregon City [in the Willamette Valley] if we had kept on the old road down the Columbia River," as she wrote. "But a three or four trains of emigrants we decoyed off by a rascally fellow who came out from the settlement in Oregon assuring us that he had found a new cut-off, that if we would follow him we would be in the settlement long before those who had gone down the Columbia. This was in August. The idea of shortening a long journey caused us to yield to his advice."

The short-cut recommended by this "rascally fellow" was the Applegate Cut-off, an alternate route into Oregon that was used for the first time in 1846. Instead of heading northwest from southern Idaho toward the Columbia River, the Applegate Cut-off veered south, crossing the upper part of what is now Nevada and the northeastern corner of California before entering western Oregon from the south. The settlers saw that the Applegate Cut-off offered one big advantage: They would avoid The Dalles, one of the most difficult points along the Oregon Trail. At The Dalles, where a smaller river flowed into the Columbia through a

steep gorge, settlers and their wagons had to negotiate a dreadful stretch of rapids in ferries or Indian canoes. Many lives and much property were lost at The Dallas.

Eager to avoid this dangerous bottleneck, Tabitha Brown, Virgil Pringle, and a number of other emigrants decided to try the Applegate Cut-off. "Our sufferings from that time," wrote Tabitha later, "no tongue can tell." The "rascally fellow" who had lured them onto the cut-off "robbed us of what he could by lying and left us to the depredations of Indians and wild beasts, and to starvation." Soon after leaving the main trail, the travelers found themselves crossing the Black Rock Desert. Virgil Pringle wrote, "This desert is perfectly sterile, producing nothing but grease-wood and sage, and some of it perfectly barren and the ground very salt. . . . The mountains barren and dark looking rocks." Tabitha later recalled, "We had sixty miles of desert wihout grass or water."

Progress was slow. On October 19 another emigrant, a 14-year-old girl, died and was buried beside the trail. The rest pushed on, guarding the cattle every night to keep them from being shot or stolen by the Klamath and Rogue River Indians of southern Oregon, who were opposed to white settlement in their lands. Late in October the emigrants spent nearly a week forcing their way through a ridge of the Umpqua Mountains. Pringle's diary says, "We were occupied in making 5 miles to the foot of Umpque Mountain and working the road through the pass, which is nearly impassable. Started through on Monday morning and reached the opposite plain on Friday night after a series of hardships, break-downs and being constantly wet and laboring hard and very little to eat, the provision being exhausted in the whole company. We ate our last the evening we got through. The wet season commenced the second day after we started through the mountains. . . . There is great loss of property and suffering, no bread, live altogether on beef. Leave one wagon."

"I rode through in three days," wrote Tabitha of the grim Umpqua crossing,

*at the risk of my life, on horseback, having lost my wagon and all that I had but the horse I was on. Our families were the first that started into the canyon, so we got through the mud and rocks much better than those that came afterward. The canyon was strewn with dead cattle, broken wagons, beds, clothing and everything but provisions, of which we were destitute. Some people were in the canyon two and*

*three weeks before they could get through. Some died without any warning, from fatigue and starvation. Others ate the flesh of cattle that were lying dead by the wayside.*

November saw the emigrants winding through the twists and turns of Cow Creek Canyon, where they had to cross the creek 39 times. Wading shoulder-deep in the icy water, women carried bundles of possessions on their heads. They were almost out of food. The Pringles had to stay behind to try to save their worn-out cattle, but they urged Tabitha and Captain Brown to ride ahead, hoping that they could get help from the settlements farther north along the Willamette. The Pringles gave Tabitha part of their scanty supply of provisions; she and Captain Brown had three slices of bacon and a cup of tea. "We saddled our horses and rode off," she said, "not knowing that we should ever see each other again."

Along the way, Captain Brown became so sick that he could barely stay on his horse, and he and Tabitha lost sight of the other emigrants. As night was falling, they rode into "a wide, extensive, solitary place, and no wagons in sight." Captain Brown fell unconscious, and Tabitha made camp. Her plight was desperate: "Worse than alone, in a savage wilderness, without food, without fire, cold and shivering, wolves fighting and howling all around me." By the next morning, however, Captain Brown had begun to recover, and he and Tabitha fell in with some other members of their party. Soon they were rejoined by the Pringles. They discovered that Indians had killed several members of the wagon train. "The rest of the emigrants," Tabitha soberly recorded, "escaped with their lives."

After another grueling mountain crossing, the emigrants were nearly at the end of their strength. It was now December. Snow was falling, and they were out of food. In their darkest hour, they were saved—and by none other than Orus Brown. He had stayed on the main route of the Oregon Trail and had reached the Willamette Valley settlements in September. Learning that a party of emigrants had taken the Applegate Cut-off, he had come south in the hope of finding and helping his relatives. "Who can realize the joy?" wrote Tabitha of their reunion. A few weeks later, the weary, hungry emigrants reached the first white settlements in the southern part of the Willamette Valley. "On Christmas Day at 2 o'clock I entered the house of a Methodist minister, the first house I had set my feet in for nine months," Tabitha Brown said. She

and Captain Brown spent the whole winter in the minister's house. The minister asked Tabitha to take over as cook and housekeeper. "His wife," Tabitha wrote contemptuously, "was as ignorant and useless as a heathen goddess." Tabitha had little patience with women who did not know how to get things done.

Tabitha had lost almost everything she owned, arriving in her new home a pauper. Taking inventory of her scanty possessions, she felt what she thought to be a button in the end of one of the fingers of her glove. It proved to be a picayune—a coin of the time, worth six-and-a-quarter cents: all the money she had in the world. She used it to buy three needles and traded a few bits of her old clothes to some Indian women for buckskins. With the needles and the skins she began making gloves and selling them to "the Oregon ladies and gentlemen." Soon she was earning enough money to support herself.

In the fall of 1847, while visiting Orus Brown and his family near a settlement called Forest Grove, Tabitha met the Reverend Harvey Clark and his wife, Emmeline, missionaries who had come to the Oregon Territory in 1840. She and the Clarks became close friends. One day they were discussing the sad fact that many emigrant children had been left orphans by their parents' deaths during the trail crossing. Tabitha and the Clarks decided to do something to help these unfortunate children. They founded the Orphan Asylum in Forest Grove; it consisted of a log house where Tabitha cared for and taught 15 or 20 orphans. In 1848 some emigrant men abandoned their families to go to California for the gold rush, and Tabitha took in more homeless and needy children.

In 1849, community leaders decided to establish a school on the site of the Orphan Asylum. The Tualatin Academy—named for the nearby Tualatin River—was founded in 1849, making it one of the oldest schools in the Northwest. Tabitha Brown, who by this time was known to all as "Grandma Brown," remained closely involved in the affairs of the academy and managed a boarding house for students. Through careful management of a small dairy herd and some real estate investments, she built up a comfortable income and donated several hundred dollars toward the cost of a frame building to replace the academy's original log cabin. The new building was completed in 1850; it still stands on the campus of Pacific University, which was established in 1854 as part of the academy. Tabitha Brown considered making a trip to the East Coast to raise funds for Pacific University, but she gave up the idea, deciding that she was needed

to look after her students— especially the female students. At that time many girls found it hard to go to school because they could not find a suitable place to live near a school; Tabitha was proud of her role in helping young women obtain an education.

In 1854, Tabitha wrote a letter to her Moffatt relatives in Massachusetts, describing her ordeal on the Applegate Cut-off and her life in Oregon. Replied one of her nieces, "When your kind, interesting letter was handed in, you can hardly imagine with what eager anxiety and fear your letter was perused. Sometimes we were almost afraid to read one more line. Our hearts almost ceased to beat." Tabitha's letter was later published in Massachusetts, where she was known as the "Brimfield heroine."

At the age of 77, Tabitha moved to Salem to live with the Pringles. She was getting older, as she confessed in her last letter to Massachusetts, dated January 25, 1858: "Father Time is no respecter of persons; he is busily engaged in drawing furrows and disfiguring our faces to convince me that we are but mortal. Our

*Tabitha Brown founded her school in a log cabin and rejoiced when this frame building was completed in 1850. Now called Old College Hall, it is the oldest building on the campus of Pacific University and one of the oldest educational buildings in the West.*
(Photo by C/Z HARRIS)

*Relics of "Grandma Brown," as Tabitha was called, are displayed in the Pacific University Museum. The collection includes her violin, books she used to teach her orphaned students, and, at the lower left, her good black cap.*
(Courtesy Pacific University Museum, photo by C/Z HARRIS)

next change will be from mortality to immortality. Oh, that we may all be prepared for this great and lasting change!"

Tabitha expected to visit her beloved Forest Grove in the spring, but she never made that last trip. She died in Salem on May 4, 1858 and was buried in the Pioneer Cemetery there. In 1987 the Oregon legislature named Tabitha Brown "Mother of Oregon" for her role in advancing culture and community in the territory's early days.

# Chronology

| | |
|---|---|
| **May 1, 1780** | Tabitha Moffatt born in Brimfield, Massachusetts |
| **1799** | marries Reverend Clark Brown |
| **1817** | husband dies; Tabitha becomes a schoolteacher |
| **1846** | crosses country to Oregon in wagon train, arrives in Salem on Christmas Day |
| **1847** | with missionary Harvey Clark, founds Orphan Asylum in Forest Grove |
| **1849** | orphanage becomes Tualatin Academy, later Pacific University |
| **1857** | moves to Salem |
| **May 4, 1858** | Tabitha Brown dies in Salem |
| **1987** | is named "Mother of Oregon" by state legislature |

# Further Reading

Butruille, Susan. *Women's Voices from the Oregon Trail.* Boise, Idaho: Tamarack Books, 1993. Includes several brief quotes from Tabitha Brown's letters.

Holmes, Kenneth L. *Covered Wagon Women, Vol. I.* Glendale, Cal.: A. H. Clark Co., 1983. Includes a short profile of Tabitha Brown.

Platz, Celista and Judith Young. *The Brown Family History, II.* Newton, Kansas: Mennonite Press, 1992. A thick volume of genealogy; hard to find and not likely to interest nonspecialists; contains some of Tabitha Brown's letters.

# Louise Amelia Clappe
# Seeing the Elephant
# (1819–1906)

*After word leaked out that gold had been discovered at Sutter's Mill, the overland route to California was clogged with optimistic miners making their way through the Rocky Mountains and the Sierra Nevada. The diggings were located in remote mountain gorges that could be reached only by muleback.*
(Courtesy Oregon Historical Society)

───────

*A* Swiss immigrant named John Augustus Sutter was indirectly responsible for the rapid growth of California's population in the 1850s. Sutter arrived in California in 1839 and built a large settlement along the American River in the Sacramento Valley.

───────

Unfortunately, no picture of Louise Clappe exists.

He had a fort, a ranch, and orchards, and a community of workers. In 1848, one of these workers was helping to build a sawmill and found some flakes of yellow metal: gold. Sutter tried to keep the discovery a secret, but word leaked out. A California newspaper reported, "The whole country, from San Francisco to Los Angeles and from the sea shore to the base of the Sierra Nevada, resounds with the sordid cry of, '*gold!* GOLD! GOLD!'" In September word of the find—along with a box of gold nuggets—reached the eastern United States, and the gold rush was on.

Within a month more than 60 ships were headed south through the Atlantic Ocean, bound for the treacherous waters around Cape Horn at the tip of South America and then the long journey north through the Pacific to San Francisco. Those who could not afford the sea passage made their way overland through Utah, Nevada, and the Sierra Nevada range—some 5,000 thousand wagons were on the move by May 1849. Tens of thousands of people arrived in California in 1849 and scrambled to stake claims along the rivers that flowed down the western slope of the Sierra Nevada. These hopeful immigrants were called the Forty-Niners. Most were men, but among them were a few women, one of whom left a vivid description of life in "the diggings."

Louise Amelia Knapp Smith was born in Elizabeth, New Jersey in 1819, the daughter of Moses and Lois Lee Smith. She had two brothers, Charles and Henry, and a younger sister, Mary Jane (called Molly). Louise's father died when she was was quite young, and when she was 17 she lost her mother as well. Relatives sent Louise to New England, where she received the best education available to young women of her day. In 1839–40 she attended the Amherst Academy in Massachusetts. Among her fellow students was Emily Dickinson, later a noted poet; her teachers included Edward Hitchcock, a leading scholar and scientist.

Another influence on Louise's mind was a man named Alexander Hill Everett, whom she met during a stagecoach trip. The two corresponded for years. Everett, who was 29 years older than Louise, called himself her "father confessor" and urged her to develop her writing abilities. "If you were to add to the love of reading the habit of writing," he wrote to her in 1839, "you would find a new and inexhaustible source of comfort and satisfaction opening upon you." Louise followed Everett's advice and began

honing her composition skills, especially in her frequent letters to him. Everett went to China as one of the first U.S. diplomats to that country; he died there in 1847. Soon after learning of his death, Louise married Dr. Fayette Clappe, and in 1849 she traveled with him on the ship *Manila* around the Horn to San Francisco.

To Louise Clappe, San Francisco seemed magical: It had sprung into existence so quickly. She wrote that

> *there is a certain fascination about the place, which our friends in the States find it difficult to comprehend. For what with its many-costumed, many-tongued, many-visaged population; its flashy looking squares, built one day and burnt the next; its wickedly beautiful gambling houses; its gay stores where the richest productions of every nation can be found, and its wild, free, unconventional style of living, it possesses for the young adventurer especially a strange charm.*

The Clappes had intended to live in San Francisco, but the cool, foggy climate proved bad for the doctor's health, and he was unable to practice medicine. He heard that doctors were needed up at the diggings and believed that the higher, drier climate of the mountains would do him good, so in June 1851 he set off for a mining camp called Rich Bar on the Feather River, just 50 miles from the summit of the Sierra Nevada. He set himself up in business there and sent for Louise to join him.

The idea appealed to Louise, who wrote to her sister, "You know that I am a regular Nomad in my passion for wandering." She had already spent part of the summer on a ranch near Marysville. From there she set out up the mountain road in a mule-drawn wagon. When the road ended, Dr. Clappe was waiting to guide her the rest of the way on muleback. Rich Bar lay in a deep gorge high in the mountains; there was no road into the place until 1909. They followed a narrow pack trail through the forests of the Sierra Nevada. Wrote Louise to Molly:

> *I wish I could give you some faint idea of the majestic solitudes through which we passed; where the pine trees rise so grandly in their awful height, that they seem looking into Heaven itself. Hardly a living thing disturbed this solemnly beautiful wilderness. Now and then a tiny lizard glanced in and out among the mossy roots of the old trees, or a golden butterfly flitted languidly from blossom to blossom . . . Two or three times, in the radiant distance, we descried a stately deer, which, framed in by embowering leaves, and motionless as a tableau, gazed at us for a moment with its large, limpid eyes, then bounded*

*away with the speed of light into the evergreen depths of those glorious old woods.*

The journey was not all ease and beauty. Louise was plagued by fleas and alarmed by the growling of grizzly bears around the campfire at night. "But what a lovely sight greeted our enchanted eyes, as we stopped for a few moments on the summit of the hill leading into Rich Bar," she wrote. "Deep in the shadowy nooks of the far down valleys, like wasted jewels dropped from the radiant sky above, lay half a dozen blue-bosomed lagoons, glittering and gleaming and sparkling in the sunlight, as though each tiny wavelet were formed of rifted diamonds. It was worth the whole wearisome journey, danger from Indians, grizzly bears, sleeping under the stars, and all, to behold the beautiful vision." Then Dr. Clappe pointed out a rattlesnake, and Louise dug her heels into her mule and galloped away in terror.

Rich Bar was a typical mining camp, a single muddy street lined with tents and hastily built shacks. There were no churches or schools. The chief public building was the canvas-fronted Empire Hotel, which had a saloon and a gambling room. About a thousand men lived in and around Rich Bar. Louise's arrival increased the female population to four—one of whom soon died.

Louise sought relief from her loneliness by writing long, chatty letters to her sister Molly. She used the pen name "Dame Shirley," probably because in the back of her mind she intended the letters to be published and did not want her own name to appear in the newspapers; as Dame Shirley, she had already published a few essays in the *Marysville Herald*. Louise sent Molly 23 letters from the diggings, covering the period from her arrival at Rich Bar in September 1851 to November 1852. She tried to make her letters an accurate reflection of life at the diggings: "I am bound, Molly, by promise to give you a true picture (as much as in me lies) of mining life and its peculiar temptations, nothing extenuating, nor setting down aught in malice." The most noteworthy feature of the letters, though, is not the accuracy of their detail but their sly humor. Louise Clappe was amused by the absurdities of life and the foibles of human nature, and she shared her good-hearted amusement with Molly.

Louise's husband and his partner held their medical practice in a canvas shelter with a dirt floor and a few boxes for chairs. Dr. Clappe was shocked and his partner was furious when Louise collapsed in laughter at the sight of this "office." Drinking and

*A typical mining camp in the winter of 1849: a swampy street, hastily built businesses, and a lean, forlorn-looking miner astride a scrawny mule.*
(Courtesy Oregon Historical Society)

gambling were the miners' principal recreations, and these pastimes often led to brawls. Clappe was kept busy stitching up stab wounds and digging bullets out of his patients.

Soon the Clappes moved to a sort of suburb of Rich Bar, a sandbar called Indian Bar that was, wrote Louise, "as large as a poor widow's potato patch, walled in by sky-kissing hills." So deep in the gorge was Indian Bar that at mid-summer the sun shone in for only two hours a day. The rest of the time the bottom of the gorge was wrapped in shadowy gloom.

Louise and Dr. Clappe set up housekeeping in a one-room cabin. She even had furniture: a bed of logs covered with pine boughs and a table and four chairs, made as payment by two miners from whom her husband had removed bullets. "Really, everybody

ought to go to the mines, just to see how little it takes to make people comfortable in the world," Louise declared. Her cooking kit consisted of an iron dipper, a brass kettle, and a skillet made out of an old shovel. The Empire Hotel's cook, Ned, made the Clappes a delicious feast to celebrate the completion of their cabin. "As long as I live," wrote Louise, "I shall never forget that meal." Ned also gave them a housewarming present—a gaudy vase, which he clearly regarded as a great treasure. The Clappes thought it was ugly but accepted it to avoid hurting Ned's feelings.

In her letters to Molly, Louise tried to convey the flavor of life in the mountains. She talked about the two grizzly cubs taken as pets by one of the miners. She wrote about the tragic death of a young mother, one of the few women in Rich Bar, and of how the grief-stricken widower was left with a six-year-old daughter, whom he did not even know how to dress. After a visit to a nearby Indian encampment, she told Molly how the Indian women ground acorns into flour and made pudding from them. The Indians were part of her everyday life: "Hardly a day passes during which there are not three or four of them on this Bar. They often come into the cabin, and I never order them away, as most others do, for their childish curiosity amuses me, and as yet they have not been troublesome."

Louise tried her hand at panning for gold. As a "mineress," she reported, she had found about $3.25 in gold dust. "I wet my feet, tore my dress, spoilt a new pair of gloves, nearly froze my fingers, got an awful headache, took cold and lost a valuable breastpin, in this my labor of love," Louise wrote of her experience. She sent the gold dust to Molly and said "I can assure you that it is the last golden handiwork you will ever receive from 'Dame Shirley.'"

Rich Bar offered little in the way of diversion, reported Louise: "no newspapers, no shopping, calling, nor gossiping, little tea-drinkings; no parties, no balls, no picnics, no tableaux, no charades, no latest fashions, no daily mail (we have an express once a month), no promenades, no rides or drives; no vegetables but potatoes and onions, no milk, no eggs, no *nothing*." When the potatoes and onions ran out, they had only hard hams, salty barreled pork, and salted mackerel to eat for months on end. When a mule train finally arrived with provisions, the men immediately spent all their money on butter, potatoes, and onions and started cooking at once. "Such a smell of fried onions, as instanteously rose upon the fragrant California air,

*"Amusements in the Mines," included bathing and washing clothes in the river, cooking over an open fire, mending clothing and equipment worn by long, hard use, and fighting off grizzly bears. Louise never confronted a bear in her home, but she was quite familiar with these other scenes from mining life.*
(Courtesy Oregon Historical Society)

and ascended gratefully into the blue California Heaven, was, I think, never experienced before," Louise wrote.

The miners' Christmas was a memorable occasion. It started peacefully enough, with an oyster supper in the Empire Hotel. Toasts were drunk, and everybody beamed with good fellowship. The miners began dancing. Because there were no women, they had to dance with each other; those repesenting women draped pieces of red calico over their arms. The party grew drunker and livelier, and the Clappes made their exit. The miners went on drinking and carousing for three days, until they passed out on the hotel floor. A few got so drunk that they tried to go boating on the river, and there were several drownings.

According to Louise, the first few miners who reached the river in 1850 had made thousands of dollars in gold but lost it all gambling. Those who came later found that the diggings were not as rich as had been supposed. In the spring of 1852, the miners realized that the diggings were not going to produce much gold. Tempers rose, and an ugly spirit of violence and frontier justice took hold of Rich Bar.

An angry mob accused a man of stealing $400; he was horse-whipped and sent away. Another man, accused of stealing $1,800, was not so lucky. He was hanged. Louise described the scene: "The

*By 1850, some of the Forty-Niners were already on their way home. Louise Clappe reported that although a few of them had made thousands of dollars, many had nothing to show for their toil in the gold fields.*
(Courtesy Oregon Historical Society)

whole affair, indeed, was a piece of cruel butchery, though *that* was not intentional, but arose from the ignorance of those who made the preparations. In truth, life was only crushed out of him, by hauling the writhing body up and down several times in succession, by the rope which was wound around a large bough of his green-leafed gallows." Some men shouted and laughed at the spectacle.

After the people of Rich Bar passed a law that no foreigners could mine there, the Spanish and Mexican miners moved to Indian Bar. The Anglos and the Spanish were frequently at each other's throats. A Yankee stabbed a Spaniard, a Spaniard stabbed an American in retaliation, and a riot broke out. All the Spanish were rounded up, stripped of their property, and driven away; two of them were whipped.

Louise described the season of violence to her sister:

*We have lived through so much excitement for the last three weeks, dear M., that I almost shrink from relating the gloomy events which have marked the flight. But if I leave out the darker shades of our mountain life, the picture will be incomplete. In the short space of twenty-four days, we have had murders, fearful accidents, bloody deaths, a mob, whippings, a hanging, an attempt at suicide, and a fatal duel.*

On the Fourth of July the miners held a banquet to restore order. Louise made a flag out of faded red, white, and blue cloth, with a single gold star. She also wrote a festive poem that was read aloud as part of the celebration:

*Ye are welcome, merry miners! in your blue and*
*    red shirts, all.*
*Ye are welcome, 'mid these golden hills, to*
*    your nation's Festival.*
*Though ye've not shaved your savage lips, nor*
*    cut your barbarous hair—*
*Ye are welcome, merry miners! all bearded as*
*    ye are.*

*For now the banner of the free is in very deed*
*    your own,*
*And 'mid the brotherhood of States, not ours,*
*    the feeblest one.*
*Then proudly shout, ye bushy men, with*
*    throats all brown and bare,*

# Louise Amelia Clappe

*For lo! from 'midst our flag's brave blue,*
*leaps out a golden star!*

In November, Lousie sat on a cigar box in her cabin, gazing out at the deserted diggings, which were covered with litter of bottles, oyster-cans, sardine boxes, and fruit jars, all dusted with a light fall of snow. By now, almost everyone had given up on Rich Bar. The mining equipment that had cost $3,000 and taken a year to build had unearthed only $41.70 worth of gold. Only 20 miners remained. The Clappes were about to leave. Wrote Louise:

> *My heart is heavy at the thought of departing forever from this place. I like this wild and barbarous life; I leave it with regret. The solemn fir trees . . . the watching hills, and the calmly beautiful river, seem to gaze sorrowfully at me, as I stand in the moon-lighted midnight, to bid them farewell. . . . Yes, Molly, smile if you will at my folly, but I go from the mountains with a deep heart of sorrow. I look kindly to this existence, which to you seems so sordid and mean. Here, at least, I have been contented. . . . You would hardly recognize the feeble and half-dying invalid, who drooped languidly out of sight, as night shut down between your straining gaze and the good ship Manilla, as she wafted her far away from her Atlantic home, in the person of your now perfectly healthy sister.*

A few days after the Clappes left, a great storm closed down all the trails for days. But by then Louise Clappe was far down the valley. She never went back to the mines or the mountains. Her marriage was not a happy one, and she was divorced from Dr. Clappe in 1857. She became a teacher at the Denman Grammar School in San Francisco and taught there for 20 years. Her closest friends were former students and their families; she corresponded with many of her pupils long after they had left school.

Louise Clappe retired from teaching in 1878 and returned to the East Coast. She lived for a time with a niece in New York City and spent her final years in a nursing home in Morristown, New Jersey where she died on February 9, 1906. Louise's letters from Alexander Everett, cherished by her for decades, were found among her possessions after her death. Other residents of the home later recalled that Clappe had taken great delight in writing and directing plays for them.

In one of her letters to Molly, Louise had confided her literary ambitions: "I would gladly write something which the world would not willingly let die." Although her essays and poems were never published, the "Shirley letters" have kept Louise Clappe's

dream alive. Published in 1854–55 in a California magazine called *The Pioneer*, they were widely read. Some of the stories of Bret Harte, a noted writer of western tales, are thought to have been inspired by "Shirley's" descriptions of the miners. The Shirley letters were first published in book form in 1933. They remain a valuable source of information for historians and researchers. During the California gold rush, people who went to the mines said that they had "seen the elephant"—in other words, they had seen a remarkable sight. Louise Clappe not only saw the elephant but described it so vividly that readers today can see it through her eyes.

# Chronology

| | |
|---|---|
| **1819** | Louise Amelia Knapp Smith born in Elizabeth, New Jersey |
| **1839–40** | attends Amherst Academy in Massachusetts |
| **1849** | comes to San Francisco with husband, Dr. Fayette Clappe |
| **1851** | goes to mining camps along Feather River in September |
| **1852** | comes out of mining camps in November |
| **1854–55** | "Dame Shirley" letters published in *The Pioneer* |
| **1857** | divorces Clappe, begins teaching school in San Francisco |
| **1878** | returns to East Coast |
| **Feb. 9, 1906** | Louise Amelia Clappe dies in Morristown, New Jersey |
| **1933** | first edition of *The Shirley Letters* published |

# Further Reading

Clappe, Louise. *The Shirley Letters from the California Mines*. New York: Knopf, 1949. The most recent book-length edition of Louise Clappe's letters from Rich Bar and Indian Bar; introduction gives biographical sketch.

Gray, Dorothy. *Women of the West*. Millbrae, Cal.: Les Femmes, 1976. Includes a short profile of Louise Clappe; good source for younger researchers.

Walker, Franklin. *San Francisco's Literary Frontier*. 2nd edition. New York: Knopf, 1943. A fascinating but hard-to-find memoir of nineteenth-century writers in California; includes a summary of Louise Clappe's life and work.

Western Writers of America. *The Women Who Made the West*. New York: Avon Books, 1980. Very readable paperback; includes a short chapter on Louise Clappe.

# Pamelia Fergus
## Doing a Man's Job
## (1824–1902)

*Pamelia Fergus became a "gold rush widow" when her husband
went off to seek his fortune. Left to cope with unfamiliar
responsibilities, Pamelia found that she was stronger, more
independent, and more capable than she had dreamed.*
(Courtesy Montana Historical Society, Helena)

*A*s Americans pushed westward during the nineteenth century,
the frontier moved constantly, and so did many of those who
settled along it. The pioneer women did not simply move once,

settling down in their new home for all time. Instead, a surprisingly large number of them moved again and again. It seemed that they were always selling off their furniture, packing up their household goods, and moving with their children to a new frontier home—a home that was always more rugged and primitive than the one they had left.

Pamelia Fergus, who pioneered in Minnesota and Montana, faced the challenge of being uprooted many times. She also endured long spells of loneliness while her husband was away hunting for gold. These separations were hard on Pamelia, but they also gave her strength. In her husband's absence, she took on new roles, acting as head of the family and manager of a business. At first terrified of being left alone, Pamelia Fergus came to enjoy her independence. Like many women in the Old West, she discovered that frontier life made harsh demands but brought unexpected rewards.

———

June 22, 1824, a baby girl called Pamelia was born to William and Mahala Dillin in a small settlement called Pamelia Township, near Lake Ontario in upstate New York. (Both the baby and the town were named after Pamelia Williams Brown, the baby's grandmother, the wife of a Revolutionary War general.) The Dillins had at least six more children, although not much is known of their history or of Pamelia's early life. As the oldest child, Pamelia undoubtedly became her mother's helper at an early age, lending a hand with the housework and caring for the younger children. She had at least a little formal schooling; she learned to read and write, although her spelling was poor. In later years she often complained that her poor arithmetic made it hard for her to manage the household finances.

When Pamelia was 18 years old, her parents, like many others in the mid-nineteenth century, decided to go west. They went only as far as Illinois, traveling by horse-drawn wagons over icy winter roads, but for Pamelia the pattern of migration had begun.

Soon after the Dillins settled in Illinois, Pamelia went to work as a housekeeper in a hotel in Moline. At Christmastime of 1844, friends introduced her to James Fergus, a 31-year-old Scotsman who had emigrated to the United States at 19 and made a career for himself operating mills and metalworks. The hard-working, ambitious Fergus was smitten with Pamelia, and the two were

married three months later. By 1850 they had three children: Mary Agnes, Luella, and Andrew.

James Fergus grew restless in Moline. He sold his share of a profitable metalworking plant and looked around for new challenges. Leaving his family in Moline, he toured the East Coast, enjoying the sights of Boston, New York, and Washington, D.C. In one of her letters to him, Pamelia said, "I rather think you will get in the notion of a big life while you are gone. I am allmost afraid you will not want to own us when you come [back]."

But Fergus's trip East convinced him that the most exciting opportunities for an enterprising fellow such as himself lay on the western frontier. In 1854 he announced that the family would be moving north into the Minnesota Territory. The move would take Pamelia far from her family and friends and from the comforts of life in a "civilized" city to settle with her small children in a cold, largely unexplored wilderness where the Native American inhabitants were hostile to white newcomers. But a wife's duty was to obey her husband, so Pamelia Fergus packed up her household goods and had them loaded onto a steamboat for the 500-mile trip.

At first the Ferguses settled in the small, brand-new town of St. Anthony, not far from the present-day site of Minneapolis–St. Paul. But after only a few months, James Fergus moved them 150 miles north to a waterfall on the Mississippi River. The region was called Little Falls, and James Fergus decided that it was ripe for development. Using his own savings and money invested by friends, he began building a dam and a sawmill to harness the power of the rushing falls, and the pioneer town of Little Falls was born.

When Pamelia and the children followed Fergus upriver to their new home, Little Falls was nothing more than a muddy field with two houses. The Fergus home was occupied not only by the Ferguses but by half a dozen or more carpenters, blacksmiths, stonemasons, and other workers in James Fergus's company. During her first few years in Little Falls, Pamelia had to cook and clean for this constantly changing crew of boarders as well as for her own family.

Before long, the Ferguses had many neighbors. The town began to grow as people settled on farms and homesites. By 1856, Little Falls had eight stores, three hotels, a school, and a newspaper. Everyone expected the dam and the mill to bring prosperity. Good times, the confident citizens of Little Falls assured one another,

were right around the corner. James and Pamelia were jubilant about their prospects. Their happiness was increased in 1857 by the birth of their fourth child, Lillie.

Then came a string of misfortunes. In the Panic of 1857, a nationwide economic depression, a number of banks failed, and operations such as Fergus's company could not obtain loans or investors. Fergus and his partners made some poor business decisions and neglected to make vital repairs to the mill. A plague of grasshoppers destroyed crops throughout the region, making provisions scarce and food prices high. Worst of all, several drastic floods washed away parts of the dam and the mill. By 1860, Fergus's company was on the rocks, and people were moving out of town in disgust.

Fergus was certain that he could bail himself and Little Falls out of trouble if only he could get his hands on some cash. Just then came news of a gold strike near Pikes Peak, Colorado. Miners, it seemed, were plucking nuggets right out of mountain streams. Here, Fergus decided, was the answer to his problems: He would go to Colorado, stake a claim, and be back with plenty of money by winter.

Pamelia Fergus did not share her husband's enthusiasm for the gold-mining scheme. Going to the gold fields was a gamble: Many prospectors returned poorer than when they had set out. And Pamelia wondered how she would take care of the children, the house, the family farm, and all of her husband's business interests while he was gone. To help her, James Fergus wrote a long letter that began, "You will find yourself as the head of a family with more responsibilities and very differently situated than what you ever was before." He then gave her pages and pages of detailed instructions about everything from stalling creditors to managing the hired hands to preventing the girls from wearing low-necked dresses. In addition, he promised to write every week to answer any questions she might have. In March 1860 he went by way of St. Anthony and Moline to Omaha, Nebraska, where he joined a wagon train bound for Colorado. With him traveled other Little Falls men, who hoped that Fergus would have better luck with gold than he had had with the dam and the mill. They arrived in Denver at the end of May.

Back in Little Falls, Pamelia Fergus grappled with such matters as taxes, hiding the books of her husband's company from his angry partners, and more flood damage to the dam. She received no word from Fergus for weeks, and wrote, "I really wish I could

see you to night if it was onley a few moments I feel very uneasy or afraid I have done wrong am very anxious to heare from you in answer to my first letter." When she finally received a letter from Fergus, he told her that mail was so slow between Little Falls and Denver that she could not rely on him for advice. "Don't fret and keep yourself in bad health about such things," he wrote later, "only do the best you can & I will be satisfied." He added that his absence would be "a great benefit" to his wife, teaching her to be independent and "do business for yourself."

As time went on, Pamelia found herself at the center of a little group of women whose husbands had followed James Fergus to the gold fields. Fergus wrote home far more often than any of the other Little Falls men, and his letters often contained news or messages for the other wives. By the fall of 1860 Pamelia was using the term "us widows" to describe herself and her friends. She told how they gathered frequently in each other's homes and pored over every letter and every scrap of information from Colorado.

The men had not yet made it rich. Wrote James Fergus to his wife:

> I like the mines as well as I Expected although the looks of the country is different and gold not quite so abundant as we expected to find it. there have been a few Excellent locations found where gold is abundant, and a few men are making fortunes but the great majority are not quite realizing their anticipations. . . . I may be disappointed, but I came here to make money and I mean to do it before I go back if possible. It will only take time, patience and some energy.

Unwilling to give up the golden dream, Fergus and the others kept moving around from place to place in the gold fields, always hoping that some new claim would make their fortunes.

Pamelia, too, needed time, patience, and some energy to cope with her responsibilities. The $300 Fergus had left her was soon gone. She took up her butter churn and started making and selling butter to earn money for the family. Pamelia also oversaw the farm, making sure that the hired hands did as Fergus had instructed regarding the planting and harvesting of crops and the care of the cattle, hogs, milk cows, and chickens. Unfortunately, the hired men were lazy and resented taking orders from a woman; she had a hard time getting them to do what she told them. Then there was the never ending housework: cleaning, laundry, cooking, sewing, supervising the children's education, and writing the weekly letter to her husband. In addition, she had

to handle a variety of business affairs that included trying to collect money owed to her husband, making excuses to those to whom her husband owed money, paying taxes on various parcels of land Fergus had bought, and answering the townspeople's increasingly anxious questions about the future of the dam and mill corporation. On top of everything else, Pamelia suffered from a long spell of poor health. Her mother and sister came up from Illinois to help her, but their presence only created more housework. Pamelia could hardly wait for James to come back in the fall and take some of the burden from her shoulders.

When he wrote to her that he planned to remain in Colorado through the winter, not returning home until the end of the following summer, she fell into a depression. "Fergus I cannot half write and it seems as though evry thing goes backwards," she wrote to him. "I hope you will live to come home." Soon, though, her spirits lifted and she regained her energy—there was plenty of work to be done and no one but herself to do it. In one of his letters Fergus cautioned her against excessive frivolity and leisure. She responded tartly, "You advise me not to be making up foolish things now Ive leisure I do not seam to have much leisure as yet, seven of us all the time and most of the time eight that is quite a family and four of them children to make wash and mend for it all takes time." Worried about her children's education, Pamelia sent Mary Agnes and Luella to stay with friends in Illinois, where they could attend a good school. Their departure eased the burden of housework a bit but made Pamelia lonelier than ever. Yet the fact that she had made such an important decision on her own meant that Pamelia was getting used to being the head of the household. Her letters reveal something else, too. As time passed, she began referring to "my garden," "my corn," "my potatoes." She was bearing more responsibility than before for the family farm, and she was feeling the pride of ownership.

Time passed slowly during the long, dark winter of 1860–61, and by February Pamelia was feeling blue. "I have nothing new to write this morning, but like to call to mind the plesent scenes of former days when we had our children around us and the future looked bright before us," she wrote to her husband. "I shall wait very anxiously for the next eight months to pass and try to make the time as short as posible." In April she wrote, "I know we like to count dollars and cents but what are they to a little enjoyment the short time we stay here on earth." To Pamelia, reuniting the family was more important than pursuing the dream of riches. And

James Fergus wrote back that he had not made out so well as he had hoped. "Let the times be ever so bad," he said, "a living can be got from the soil, but it is a very risky business getting it from the bowels of the Earth in the Rocky Mountains."

James Fergus came home from Colorado in the fall of 1861, stopping along the way in Moline to pick up his two daughters. By the time they got to Little Falls, Pamelia Fergus had been separated from her husband for 19 months and from her daughters for more than a year. Their reunion was, as James wrote to his brother in Scotland, "a happy meeting." Some of the other gold-rush widows of Little Falls were not so happy: Their husbands had remained in Colorado, despite the wives' pleas that they return.

But James Fergus was still entranced by the notion of striking it rich in the gold fields of the West. Hearing of a new gold strike along the Salmon River in a wild, as-yet-unsettled area that was to become the Idaho Territory, Fergus decided to join an expedition led by Captain James Fisk of the U.S. Army, who planned to open a northern wagon-train route from Minnesota to Idaho. The expedition set out in June 1862; Fergus had been home with his wife and family for six months. Most of the expedition's 130 men were from Minnesota, and nine were from Little Falls. Fergus became the informal leader and chief letter-writer for this local group.

For the second time, Pamelia Fergus found herself one of a townful of anxious gold-rush widows. Again her husband had prepared a lengthy list of instructions. It began: "Mrs. Fergus, I expect to be back next winter, but in case I should stay longer than I intend I leave the following memorandum for your assistance." He left her only $25 but promised to send her gold dust as soon as he found some.

Fergus's trip West was adventurous. The expedition slew hundreds of buffalo and repelled several atempts by hostile Indians to steal horses. Fergus did not think much of most of his fellow travelers. "I have often thought that Minnesota got rid of more hard cases the trip I came through than I ever saw together, broken down lumbermen that would pay nothing, broken down merchants and scalawags of all sorts," he later said. He did not group himself with the "broken down" scalawags, of course, for he still expected to win his fortune. Fergus never did get to Idaho. Hearing that the Salmon River diggings were crowded, he and most of the other Little Falls men dropped out of the expedition

at Deer Lodge, near present-day Helena, Montana, and began prospecting gold claims there.

Meanwhile, Pamelia Fergus was having adventures of her own back home. The U.S. government had failed to make its annual payment to the Indian tribes of the upper Mississippi, and trouble broke out when starving Indians began attacking white trading posts and settlements. Little Falls was all but unprotected, as the few able-bodied men who had not gone to the gold fields had gone off to fight in the Civil War. For some time, Pamelia, her children, and the other townspeople spent each night barricaded in the town courthouse for safety, returning fearfully to their farms and shops each day. Some of the Ferguses' friends on outlying farms were killed by Indians. After the army sent troops to quell the uprising, Pamelia wrote to James: "It is settled now and we are here as well as could be expected although many of our neighbours have left the country."

Mail service between Minnesota and Montana was irregular. James Fergus did not receive a letter from home until the end of January 1863, although Pamelia had written every week since his departure half a year earlier. James's letters to Pamelia arrived after long delays, and although he sent gold dust or money as often as he could, several of the letters were opened along the way, and by the time they reached Pamelia the gold or cash was gone. Often she went for months without hearing from him. "Some times it seems as if I could not wait till you come home I want to talk with you about so many things," she wrote.

By this time James Fergus had finally realized that even if he did make a big gold strike, he could not revitalize Little Falls. The town that he had founded with such high hopes was dying; its boom had turned into a bust. Fergus decided to bring his family out to Montana and make a new start there. His claims had yielded a little gold, but he supported himself chiefly by carpentry work. He wrote to Pamelia that in a single week he'd made three coffins: one for a man who drank himself to death on homemade whiskey, another for a man shot "in cold blood" by a highway man, and the third for a young, newly married man who died of "fever." Perhaps realizing that he was not painting a very attractive picture of Montana, James assured Pamelia that she and the two older girls would be able to make money as cooks, seamstresses, or laundresses. "Womens labor pays as well if not better than mens," he wrote, "and you are all workers." Pamelia did not record her immediate reaction to this alluring prospect. But she was eager

to reunite her family, in Montana if not in Minnesota. Slowly, hampered by the long delays between letters, she and James began making plans to move the family west. James did not want to come back to Minnesota; in one letter he confessed to Pamelia that he did not intend to pay all of his debts there. "I must look out for my self," he wrote. He instructed Pamelia to sell the Little Falls property and join a wagon train. But because of renewed conflict with the Indians, there was no wagon train to Montana in the summer of 1863. Pamelia and the children could not expect to travel westward until the summer of 1864.

By that time, James Fergus had relocated again, settling near a new gold strike in what became Virginia City, Montana. For once James and his partners made money: within a few months he had taken several thousands dollars' worth of gold from their claim. Cautioning Pamelia to keep this news to herself so that his creditors would not hear of his good fortune, he spoke of the glowing future that awaited them in Virginia City, where he would work the claim and Pamelia would run a boarding house.

James's letters in the fall and winter of 1863 were full of advice and instructions about preparing for the trip west. Pamelia would take a more southerly route than he had followed, passing through Iowa and Nebraska before veering north to Montana. James told her what to bring and what to sell or discard. Even sentimental items and handmade heirlooms must be sacrificed. Wrote James, "Quilts don't answer very well on the road. They get torn too easy." Pamelia was to buy sturdy wool blankets instead. He described life in a wagon train and warned her against letting the children fall off the wagon, for they would surely be run over and killed. He sent itemized lists of everything she and the children would need in their new life: clothes, kitchen implements, tools, and the like. He even told her exactly how to copy the list into a memorandum book and mark each item with a pencil when it was packed.

Pamelia did her best to follow James's many instructions, but she had one important addition of her own. She had seen a new sewing machine at the home of another Little Falls woman, and she was determined to have one for herself. Pamelia explained in several letters how useful such a machine would be—after all, she made all of the family's clothes, as well as extras such as curtains. James saw the sense in her argument and told her to order "a good strong sewing machine." Pamelia was thrilled when it arrived in

*Worth its weight in gold to Pamelia, this long-awaited sewing machine was part of the four tons of cargo she packed for her move to Montana.*
(Courtesy Montana Historical Society, Helena)

Little Falls, and all of the women and girls in town came over to see it.

In the midst of her preparations, Pamelia was confronted with an agonizing dilemma. Mary Agnes wanted to marry Robert Hamilton, a young tinsmith who had boarded in the Fergus home for some time. The couple asked for James Fergus's permission to wed, but although Pamelia repeatedly asked for his advice, he did not mention the matter in any of his letters home. Perhaps he thought that if he withheld his consent, nothing would happen.

Pamelia Fergus and her four children—accompanied by Robert Hamilton—left Little Falls in February 1864. Pamelia had not been able to sell the house and barn as Fergus had instructed, for people were leaving Little Falls and no one was moving in. She simply had the windows boarded up and told a friend to write to her if anyone showed interest in buying the property. The travelers stopped in Illinois to visit Pamelia's mother and other relatives, and from there Pamelia wrote to James, "I hasten to communicate with you though with somewhat reluctance our daughter Mary was married to R.S. Hamilton day before yesterday. I hardly know how to advise you or what to say. . . ." In truth, although Pamelia feared that James would be angry that the marriage had occurred without his consent, she welcomed Hamilton's company and assistance on the long and arduous trip west.

"I tell you," she wrote from one point along the trail, "camp life has no charm for me but the children think it is fun they want to eat all the time." Some stretches of the trail looked "Indiany," Pamelia reported, but there was no trouble. The most dramatic encounter with Indians took place one evening when a party of curious Indian women and children came into camp to examine the wagons and tents. Pamelia took out her set of false teeth, so frightening the Indians that they ran away "screaming and yelling." Some time later, however, the wagon train leader turned off the main trail after hearing reports of fighting in the Lakota hunting grounds ahead. The wagon train crawled along between the Wind River Mountains and the Bighorn Mountains across brutally rough terrain. Robert Hamilton's wagon broke down and the leader refused to wait for him to mend it; Pamelia looked back in distress as the newlyweds were left behind alone. Fortunately, Hamilton quickly repaired his broken axle, and he and Mary Agnes soon caught up with the rest of the group. Pamelia was exhausted and could hardly wait for the trip to be over. "Mother says she is so thankful we are so near she has nothing

more to say," Luella wrote to her father from the banks of the Yellowstone River. A few weeks later, on August 14, 1864, Pamelia and the children arrived in Virginia City.

Pamelia and James Fergus had spent most of the past five years apart; each had gotten used to having his or her way. Although both were happy that the family was reunited, it was not easy for them to be together again. James criticized Pamelia for having allowed Mary Agnes to get married. And Pamelia, having had to make a great many difficult decisions on her own, bristled under his criticisms. On one memorable occasion James complained that a meal was too salty, and Pamelia answered heatedly, defending herself in front of their guests. Later James wrote her a long letter of chastisement. He started with complaints about the salt and about her rudeness in talking back to him. Then he went on to outline the many ways in which she had failed to follow his instructions. "The great trouble," he wrote, "is that you pay no attention to the wishes of your husband, even to his positive direction at times. . . . You ought to be thankful that you are situated as you are and treated as you are."

Undoubtedly there were other, unrecorded conflicts between these two strong-willed people now that they were once more living under the same roof. Gradually, however, the tension died down. In the spring of 1865, James Fergus decided to move his family to Helena, the fast-growing settlement that eventually became the capital of Montana. Barely unpacked from the last move, Pamelia objected, "We are as well off here as their." Nevertheless, she obediently packed up once more, sadly leaving Mary Agnes and Robert in Virginia City.

Helena did not hold James Fergus for long. By early 1866 he had decided to try a new livelihood: ranching. With Pamelia, Luella, Andrew, and Lillie, he moved to a homestead claim outside Helena and then, in the fall of that year, the Ferguses moved again, this time to another ranch even farther from town. Here at last Pamelia hoped to put down roots. James ordered fruit trees, and together they planted an orchard.

The ranch prospered, and for a time James Fergus was content to remain on it. Luella married a Helena man. Andrew ranched land adjoining his parents' homestead. He opened a restaurant to serve the stage traffic passing through on its way to Helena, and, seeing how profitable this operation was, in 1871 James and Pamelia opened a small hotel. James was busy with ranching and with local politics,

*The main street of Helena, Montana, as it looked when Pamelia Fergus and her children arrived in 1865. Crude as it was, Helena was cosmopolitan compared with the Ferguses' next home.*
(Courtesy Montana Historical Society, Helena)

so Pamelia took over the hotel. Her husband was finally impressed by her abilities and lost no chance to praise her independence and management skills. At last, it seems, he accepted her as an equal partner.

James Fergus may have grown more tolerant and patient in his old age, but he remained restless. By 1881 he felt that western Montana was becoming too crowded and "civilized." He and Pamelia made one final move, this time to a ranch in the wide-open, empty spaces of central Montana. Pamelia's nearest neighbor in this new, windswept place was 20 miles away. For three months after moving, Pamelia's only companions were James, Andrew, and their work crew. Isolated from her friends and daughters though she was, she had the work of a new homestead to keep her busy. James wrote to one correspondent that Pamelia "works hard, doing nearly all the work for nine men, makes butter,

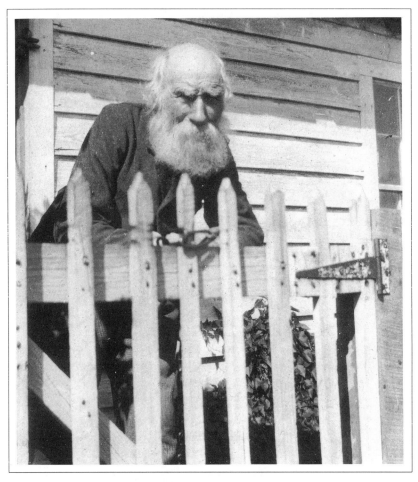

*James Fergus at his ranch, 1897. Soon after this picture was taken, Fergus dreamed of adventuring in the Klondike gold fields of Canada, saying, "We all have to die sometime."*
(Courtesy Montana Historical Society, Helena)

raises chickens, has flowers and plants indoors and out and is nearly always busy." At the time of this letter, Pamelia Fergus was almost 60 years old.

Yet the frontier, with all its discomforts, had become home to Pamelia. In 1884, the Ferguses visited their friends in Helena. James wrote to Andrew, "Mother says tell them she is tired of

staying here, wants to go somewhere, would prefer to go home; too much noise, too many houses, too many people, and too many locomotives howling around, would rather hear the coyotes." That year James and Pamelia made a trip to Portland, Oregon, and then to San Francisco. It was Pamelia's last piece of traveling. She developed breast cancer and died in Helena on October 6, 1887. James's eulogy at her funeral praised her as "an obedient child, a faithful wife, a loving mother, a true friend and an honest woman, performing her full duty in all stations in life, beloved by all, leaving not an enemy behind."

James Fergus outlived his wife by 15 years. He spent them quietly enough—although he felt a touch of his old wanderlust in 1897, when he heard of the Klondike gold strike in Canada's Yukon Territory. Once again the lure of the gold fields cast its spell, and the old man spoke of going north to find his fortune or die on the tundra. He never left the ranch, however, and died there at the age of 90 in 1902.

# Chronology

| | |
|---|---|
| **June 22, 1824** | Pamelia Dillin born in Pamelia Township, upstate New York |
| **1842** | moves with family to Illinois |
| **1845** | marries James Fergus |
| **1854** | Fergus family moves to Minnesota Territory, helps found Little Falls |
| **1857** | Lillie Fergus born; Panic of 1857 brings tough times |
| **1860** | James Fergus goes off to Colorado gold fields in March |
| **November 1861** | James Fergus returns from Colorado |
| **June 1862** | James Fergus goes to Montana gold fields |
| **February 1864** | Pamelia Fergus and children leave Little Falls |
| **August 14, 1864** | arrive in Virginia City, Montana |
| **May 1865** | Ferguses move to Helena |
| **1866** | settle on two successive ranch claims |
| **1871** | open a hotel |
| **1881** | move to ranch in central Montana |
| **1884** | travel to West Coast |
| **October 6, 1887** | Pamelia Fergus dies in Helena |
| **1902** | James Fergus dies at ranch |

# Further Reading

Armitage, Susan and Elizabeth Jameson, editors. *The Women's West*. Norman: University of Oklahoma Press, 1987. Essays about women's roles on the frontier; too scholarly for most young readers.

Peavey, Linda and Ursula Smith. *The Gold Rush Widows of Little Falls*. St. Paul: Minnesota Historical Society Press, 1990. The lives of Pamelia and James Fergus as reflected in their letters; also tells the stories of other Little Falls families; very readable.

White, Helen McCann. *Ho! For the Gold Fields: Northern Overland Wagon Trains of the 1860s*. St. Paul: Minnesota Historical Society Press, 1966. A description of wagon trains such as the ones in which James and Pamelia Fergus traveled; may be difficult to find.

# Clara Brown
# Out of Slavery
# (1803–1885)

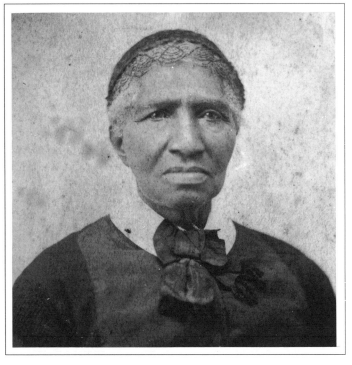

*Born a slave in Virginia, Clara Brown was in her late fifties when
she made the trek west to Colorado with a wagon train. Her life
was shaped by faith, hard work, and the search for a daughter
taken from her in a slave auction.*
(Courtesy Colorado Historical Society)

*T*he contributions of African Americans have all too often been
overlooked in the history books, but black men and women played
a significant part in the settling of the American frontier. Although
racial discrimination followed black pioneers into the West, espe-
cially in the years leading up to the Civil War, blacks found that

on the whole they enjoyed greater freedoms there than they did back East. Some of the black pioneers were escaped slaves who had fled into the wilderness. Most, however, were free blacks who went West for the same reasons whites did: for land, for a new start, for gold. One of them was a brave, hardworking woman whose decades-long search for a lost daughter led her to the mountains of Colorado.

Clara was born to a slave woman in Virginia in 1803. Little is known about her family or early life. She always claimed that there was some Cherokee blood in her ancestry, and it is true that Native Americans and black slaves sometimes intermarried in the Eastern states. Whatever her family's history may have been, Clara knew little of her father. When she was only three years old, her owner sold some of his slaves at auction. Clara's father was bought by one bidder, her mother by another. Like countless other black families, they were separated by the auctioneer's hammer, never to meet again.

Clara went with her mother; slave children under the age of 10 generally remained with their mothers. Their new master was a tobacco farmer named Ambrose Smith. In 1809, Smith took his family and slaves on the long trek west into Kentucky, which was then considered the frontier of settlement. The Smiths were religious, and under their influence Clara became a fervent Christian at a young age. Her religious faith never left her; it was a constant source of strength in a life that included many trials.

Sometime during Clara's girlhood, her mother died. At the age of 18, Clara married Richard Brown, another of Smith's slaves. They had four children: Richard, Margaret, Paulina, and Eliza Jane. For some years, Clara and her family lived in relative comfort and security on the Smith farm. The greatest tragedy they had to endure was the loss of Paulina, who drowned in a creek at the age of eight. But when Ambrose Smith died suddenly in 1835, Clara's world abruptly changed. Clara had thought that she and her husband and children would always live with the Smiths—but now Ambrose Smith's heirs turned the slaves over to an auctioneer to be sold.

For the second time, Clara's family was broken up by a slave auction. This time she could only stand by in agony as her husband and son were bought by a slave trader bound for the southern

cotton plantations. Both Clara and Richard knew that being bought as a plantation field hand amounted to a death sentence. Clara watched her kin as they were led away, knowing that they were likely to be killed by disease, overwork, cruelty, or neglect. Margaret, Eliza Jane, and Clara were all bought by different owners. As Clara was led out of the auction room, she took a last look at her daughters. She would probably never see them again.

Clara's new owner was a merchant named George Brown who lived in Russellville, Kentucky. She spent 20 years with the Browns, who treated her well and even tried to trace her husband and children. No information was ever found about Clara's husband or her son. Her daughter Margaret, she learned, had died of a respiratory infection. The fate of Eliza Jane remained a mystery. Until 1852, Eliza Jane had worked for the man who had bought her at the auction, but then she left, and no one knew where she had gone, or why. Clara's owner could not even discover whether Eliza Jane had been given her freedom or remained a slave. But a dream was kindled within Clara: someday she would find this missing daughter.

In 1857, Clara's second owner died. This time, however, his heirs had no intention of selling her. They gave her her freedom, and for the rest of her life she was careful to keep the precious papers that identified her as a free woman pinned inside her dress. She knew that without the papers, she could be seized and sold by any slave trader into whose hands she fell. The Browns also gave Clara $300, enough to help her get started in life as a free woman.

Freedom had a catch in Kentucky in 1857: The law said that freed slaves had to leave the state. Clara went to St. Louis, where she was hired as a cook by friends of her former owners. St. Louis was the biggest city on the American frontier and the jumping-off point for western settlers. Clara was fascinated by the river wharves, busy day and night with traffic up and down the Mississippi River. She learned that thousands of people, black as well as white, were crossing the river to settle in the Kansas Territory, which at that time stretched all the way to the Rocky Mountains. Clara hoped that Eliza Jane was among those who were seeking a new life in the West. She dreamed of seeing her daughter pass by in the crowds on the wharves.

Clara's employers soon moved to Leavenworth, Kansas, a prairie boom town, and Clara jumped at the chance to accompany them. At the church she attended in Leavenworth, Clara made a

friend in Becky Johnson, another former slave who worked as a laundress. Becky taught Clara how to run a laundry, and when Clara's employers moved on west to California, Clara remained in Leavenworth and earned her living as a laundress.

During the 1850s, the entire United States was caught up in the argument over slavery, and nowhere was that debate more heated than in the Kansas Territory. Northern abolitionists, dedicated to ending slavery, wanted to see Kansas become a free state. The slaveholders of the South, however, wanted Kansas to become a slave state. Each side carried out raids against the other; the violence was so extreme that the territory was called "Bleeding Kansas." Many people were certain that the growing tension between North and South would soon lead to war. In the meantime, the Kansas Territory was a dangerous place for free blacks.

Clara had learned that people were flocking to the mountains of a place called Colorado, far across the plains at the western edge of the territory, where gold had been discovered. She thought that out there in Colorado she might come across someone who had news of Eliza Jane, or perhaps even find her daughter. So, in the spring of 1859, in her late 50s, she approached the leader of a wagon train that was preparing to set out on the 700-mile journey from Leavenworth to Colorado. Clara could not afford to pay for the trip, but the wagonmaster agreed to let her come along in exchange for her services as a cook. Clara would be the only African American in the wagon train, and one of only six women.

The wagon train set out in April on a trip that tested Clara's determination and stamina. The emigrants walked every step of the way—the wagons were filled to the limit with priceless supplies. The walkers were blasted by icy storms, baked by scorching heat, smothered by dust, parched by thirst, and alarmed by the Indians who watched in silence as the wagons crawled by. They made 10 or 12 miles a day. Finally, after more than two months on the trail, they reached Denver, which was nothing more than a sprawl of log cabins along Cherry Creek. But Denver was growing fast; it was the gateway to the goldfields higher up in the mountains. Clara was pleased to see how many people passed through the region. She told everyone who would listen about her quest for Eliza Jane, but no one had met a black woman who fit Eliza Jane's description.

Clara found a job as a cook in a Denver restaurant; soon afterward she opened her own laundry. Most of the miners who came down from the diggings were unmarried, and they were

happy to pay fifty cents a shirt to have their filthy red and blue flannel shirts laundered. Clara was able to make a comfortable living and even to give generous donations to several churches. She helped establish the first Methodist church in Denver. Black and white people worshipped together. Clara found that many white people on the frontier were ready and willing to accept her as their equal. One of the first friends she made in Colorado was a German named Henry Rietze, and he remained Clara's friend for the rest of her life; other whites, too, became her friends.

The frontier was not free of racial prejudice, however. Many white pioneers feared and hated the Native Americans of the West and wanted to see them exterminated, and some hated African Americans as well. Black homesteaders were some-times run off their land by white mobs; black miners were cheated out of their claims.

Barney Ford, a black man who had escaped from slavery in the South to freedom in Canada on the Underground Railroad, came to Colorado in 1860. His experiences proved that plenty of whites still considered blacks to be their inferiors. Ford staked a claim near Pikes Peak and was working it with two young black men as helpers when he was driven off his property by a group of armed white claim-jumpers who declared that no blacks were allowed in the gold fields. Ford and his helpers fled in haste, leaving all their possessions behind. Determined to win his fortune in the gold fields, Ford prospected another claim, this one near the present-day site of Breckinridge. To protect this claim, he made a deal with a white lawyer. In exchange for 20 percent of Ford's profits, the lawyer would file the claim in his own name. The lawyer double-crossed Ford, though, and sent a sheriff to seize the claim and all the gold that Ford had taken from it, saying that it really belonged to him—and he had the title to prove it.

In 1860, Clara Brown moved about 45 miles northwest of Denver to Central City, the hub of the mountain towns and the center of the mining district. Her laundry business flourished, and once again she made many contributions to the churches that were struggling to get started in the rough, rowdy mining com-munity. She helped found the St. James Methodist Church—the church's services were held in her cabin until the buildings was completed. Although Clara was a Methodist, she also gave gener-ously to the town's first Roman Catholic Church, telling the surprised priest, "All churches do the Lord's work."

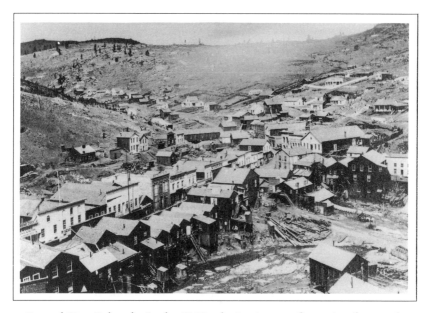

*Central City, Colorado, in the 1860s, during its transformation from rude mining camp to bustling town. Clara Brown made thousands of trips up and down the muddy streets, picking up and delivering laundry.*
(Courtesy Denver Public Library, Western History Department)

Clara lived very simply, spending little money on herself. She invested the money she earned through her ceaseless hard work in real estate. Eventually she owned a number of properties in Denver, Central City, and a handful of other communities. She also owned shares in several profitable mining claims. Even after a flood destroyed the deeds to her Denver properties, she remained comfortably well off.

During her 20 years in Central City, Clara saw the place transformed from a rough-and-ready cluster of tents and hastily built shacks to a proud town with a fine hotel, streets of handsome frame houses, and a steady stream of illustrious visitors (for whose benefit the streets were sometimes lined with bricks of solid silver). Central City's black population grew, too, especially after the Civil War freed the southern slaves to emigrate westward in search of land or opportunity. Clara's friend Barney Ford, who finally struck it rich on several claims and amassed a large fortune,

was a leader among the blacks in Colorado. Other black entrepreneurs formed the first all-black mining company in Colorado and discovered a number of rich silver lodes. These and other black residents of Denver and Central City formed a close-knit African-American community, of which Clara was a highly regarded member, much admired for her kindness and generosity. She was known to blacks and whites alike as "Aunt Clara Brown," in keeping with the old southern custom of addressing elderly black men and women as "Uncle" and "Aunt."

Over the years, Clara made a point of talking with everyone who passed through the area, white as well as black. Each time she met someone new, she hoped to hear news of Eliza Jane, but she was never able to gather any information about her long-lost daughter. In 1866, Clara went back to Kentucky, Tennessee, and Virginia to look for clues to Eliza Jane's fate. Her trip east was very different from the strenuous westward trek she had made with the wagon train less than a decade earlier. She traveled in comfort by stagecoach and train and visited a number of communities, always asking for news of her daughter. She tried to learn Eliza Jane's whereabouts by talking to ministers, postmasters, and servants in the town where Eliza Jane's last known owner had lived, but no one was able to help her. It was as though her daughter had vanished from the face of the earth.

Although Clara Brown's quest for her daughter had failed, she accomplished something remarkable in Kentucky. Seeing how many former slaves were homeless, jobless, and discouraged, she decided to take some of them back to Colorado with her. She dug deep into her savings and equipped 16 black men and women with passage money, clothing, food, and other supplies for the journey. Along the way they stopped in Leavenworth, Kansas, where Clara visited her friend Becky Johnson. In Leavenworth Clara decided that it would be cheaper to make up her own small wagon train for the rest of the journey than to pay 17 stagecoach fares. So she bought wagons, tents, and oxen, and her little caravan left Leavenworth in the summer of 1866, bound for the mountains of Colorado.

The arrival of Clara and her band of emigrants was treated as a significant local news event by the newspapers that served Denver and Central City, and before long most of the newcomers had found jobs in the area. Sadly, however, Clara discovered that she had been cheated—probably by the outfitter who sold her the wagons and oxen, who would have found it easy to take advantage

of an elderly woman who could neither read nor write. Somehow he had managed to rob her of several thousand dollars. Clara suffered another setback in 1873, when three of the houses she owned in Central City burned to the ground. At 70 years of age, she suddenly found herself in a shaky financial position. To make matters worse, her health began to fail; she suffered from swollen limbs and exhaustion, the first signs of heart disease. Nevertheless, she doggedly went back to work.

Neither age, ill health, nor money troubles could dampen the fires of Clara's charitable nature. When she learned that a large encampment of black emigrants in Kansas had been stricken by disease, she made the long, tiring journey down from the mountains to the camp, where she offered her services as a nurse. She spent most of a long, hot summer there, ministering to the nearly 5,000 sick former slaves. Upon her return home, the *Central City Register* announced: "Aunt Clara Brown, whom everybody in Central knows, returned yesterday from a visit to Kansas, whither she went to look into the condition of the colored refugees and in the interest of the sufferers generally. . . . Aunt Clara says they are an industrious and sober class of people who only ask an opportunity to make an honest living."

Clara was now past her mid-70s, and her health was growing worse. When a doctor advised her to move to a lower altitude, a white friend in Denver offered a house in which she could live rent-free for the rest of her life. The offer was welcome, for Clara's savings and property were gone. Some of her wealth had been lost or stolen, but much had been given to help others over the years. Now she discovered that there were many people in Colorado who wanted to help her.

In 1881 Clara was notified that she had been named a member of the Society of Colorado Pioneers. The society had at first admitted only white men, but in 1881 the rules were changed to admit women and people of color. Clara was too ill to attend the society's banquet, but Barney Ford and his wife, who had also been named Pioneers, were present, and Clara rejoiced at this sign of her people's growing equality.

The following year Clara received a letter from her Kansas friend Becky Johnson, who had moved to Council Bluffs, Iowa. Clara got someone to read the letter to her, and the news electrified her: Becky had found Eliza Jane. Clara's daughter was a widow with grown children, living in Council Bluffs, where she worked as a laundress.

She had come West after her husband was killed in the Civil War. After 47 years of separation, Clara had found her lost Eliza Jane.

Old and ill as she was, Clara managed to make the trip to Council Bluffs, helped by kindly loans from some of Denver's leading citizens. Her reunion with Eliza Jane was joyous, and

*A drawing of "Aunt Clara Brown" appeared in the Denver*
Tribune-Republican *in 1890. The accompanying article concluded: "She was always the first to nurse a sick miner or the wife of one, and her deeds of charity were numerous."*
(Courtesy Colorado Historical Society)

when she returned to Denver a few months later, she was accompanied by her granddaughter, who took over the task of caring for her ailing grandmother. Clara and Eliza Jane published a short note in the *Denver Republican* in April 1882, thanking all those in Colorado and Iowa who had made their reunion possible.

Clara's health declined quickly. Within a year of her visit to Iowa, she was unable to leave her bed. In the summer of 1885, Eliza Jane came to Denver to be with her mother in her final months. Clara's financial situation was made more comfortable by a gift of money from the Society of Colorado Pioneers. Her last outing was to a banquet held by the society in September 1885; she was carried into the banquet room on a padded chair and treated as an honored guest.

Clara Brown died on October 23 at the age of 83. The members of the Society of Colorado Pioneers paid for a stately funeral. Today Clara Brown is remembered not just as a pioneer woman of unusual faith and strength but as a benefactor to many people of color in the early West. The memorial of which she would be proudest is a plaque on the front of the St. James Methodist Church in Central City, which reads, "This church, one of the earliest in Colorado, was organized July 10–11, 1859. . . . For a while, services were held in the home of Aunt Clara Brown, a former slave. . . ."

# Chronology

| | |
|---:|---|
| **1803** | Clara born a slave in Virginia |
| **1806** | sold, along with mother, to tobacco farmer |
| **1809** | taken by owner to Kentucky |
| **1820(?)** | marries a slave named Richard Brown |
| **1835** | family separated at slave auction |
| **1857** | receives freedom, moves to Missouri |
| **1859** | travels to Colorado with wagon train |
| **1866** | leads wagon train of black settlers to Colorado |
| **1879** | helps with relief of black emigrants in Kansas |
| **1881** | made member of Society of Colorado Pioneers |
| **1882** | reunited with long-lost daughter in Iowa |
| **October 23, 1885** | Clara Brown dies in Denver |

# Further Reading

Bruyn, Kathleen. *"Aunt" Clara Brown*. Boulder, Col.: Pruett Publishing Co., 1970. The only full-length biography of Clara Brown; much of it is fictionalized, but the author clearly identifies her sources and indicates where she has filled in gaps with her own imagination.

Katz, William Loren. *The Black West*. Seattle: Open Hand Publishing, 1987. An excellent resource for anyone interested in the African-American experience on the frontier; contains a brief account of Clara Brown's life.

# Martha Gay Masterson
# Fifty Years on the Frontier
# (1837–1916)

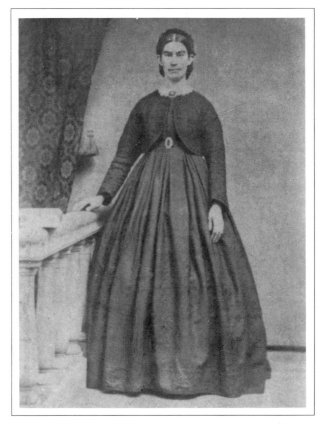

*Martha Gay married at the age of 33 and then moved 20
times in 20 years, following her husband to a series of
new homesteads throughout the Pacific Northwest.*
(Courtesy Lois Barton and Spencer Butte Press)

*T*he pioneer women were historians. They left records of their
experiences in letters and diaries written along the trail or on the
new homestead. They told and retold stories to their children and
grandchildren. Sometimes, years later, they were interviewed for

newspaper articles about "the old days." And sometimes they wrote their own autobiographies, looking back over the years to their experiences on the frontier. In her old age, Martha Gay Masterson of Oregon was "a wonderful storyteller," one of her great-nieces later recalled. Martha used to gather the children around her under a tree and tell stories of her adventures long ago on the Oregon Trail. She not only told her stories, she also wrote them down, filling three writing tablets with her life history from childhood through maturity. Her account shows us a teenage girl crossing the country on the Oregon Trail, a young woman coming of age on a pioneer homestead, and a wife and mother who struggled to make a home in the booming, bustling Northwest.

Martha Ann Gay was born in Arkansas in November of 1837 to Martin and Ann Gay; her family moved to Missouri when she was a baby. She was the Gays' sixth child. Martha had an older sister, Mary Frances, who was called Mamie. Although the two girls longed for a sister, their mother kept bearing sons. By 1851, Mamie and Martha had nine brothers.

Martha had vivid memories of her early childhood on a farm in Missouri: a prairie wolf that leaped into the Gays' yard, her chores with the family's dairy cattle, exploring nearby caves with Mamie and her brothers, and a long-nosed, sharp-chinned schoolteacher who wore a shiny black coat. "He marched around occasionally," Martha wrote of this teacher, "and if he discovered any fun or idleness going on, down would come that switch causing the juveniles to draw themselves into small parcels to evade the rod."

After losing money in an ill-fated attempt to ship hogs to New Orleans, Martin Gay had to sell his livestock, and in 1846 the family moved into Springfield, Missouri. Martin Gay went to work as a carpenter, and the children enrolled in a good school. "Professor Beck and his cultured wife were from New York," said Martha, "and that alone was in those days proof of its standing as a superior institution of learning."

Things went well for the Gays in Springfield. They were "happy and prosperous and the future looked bright." Then, when Martha was about 12, her father came down with "the Western fever" and decided to emigrate to the Oregon Territory. "Mother was not willing to go," Martha remembered. "She did not want to undertake the long and dangerous journey with a large family of small

children. . . . She begged father to give up the notion but he could not." Martin Gay called his children together and told them about "the beautiful Willamette Valley, the great forests and the snow-capped mountains." The children failed to share his enthusiasm and said that they would rather stay in Springfield with their friends. "But children were expected to do as their parents said in those days and father said we must come," wrote Martha.

Having decided to go west, the Gays were plunged into a flurry of preparations. "The clothing for such a journey for such a family was no small matter," said Martha. "The provisions were enough to stock a small grocery store." People came from far and near to beg the Gays to give up their wild plan. "They said our family would be slain by Indians or perish on the deserts," said Martha. For more than a year she and Mamie and their mother sewed dozens of garments "of all sizes and colors," while their friends joined them for sewing bees and cried at the thought of the gruesome fate that undoubtedly awaited the Gays out on the plains.

The family's departure in April of 1851 was a community affair: sermons were preached, prayers were said, businesses closed down, and "everybody came to say goodbye to us," as Martha recalled. "We took a last look at all, then closed our eyes on the scene and moved forward. Their wails reached us as we moved away." The Gays, in their four wagons, joined a train of about 27 wagons and headed west.

The first part of the trip was marked by several incidents. One day the emigrants were startled by the sudden appearance of "five hundred Indian warriors in paint and feathers, all on horseback and armed with guns, bows and arrows, tomahawks, and scalping knives." The wagon train was not under attack; the Indians were merely celebrating their victory in a battle with another tribe. Later, however, the emigrants had several close brushes with Indians intent on stealing their horses or livestock. Once the wagon train was fired on at night, and in the morning Martha found two arrows sticking through the canvas cover of the wagon near where she had been sleeping.

Life and death were always close at hand. Along the way, Martha's mother gave birth to her twelfth child. To Martha's great delight, the baby was a girl. She was named Sarah Julia but was always called "Pink." The wagonmaster's two-year-old son fell from his wagon and was seriously injured when the wheels rolled over him. He was lucky; he lived. "We often saw human skulls bleached by sun and storms

lying scattered around," Martha said. She and the other young people would pick up the skulls, read the verses that some earlier traveler had written on them, and perhaps add a line. Martha later described the heartaches of the Oregon Trail this way:

> *We saw many new graves and heard of sickness and sorrow on every hand. Teams fell by the wayside. Provisions gave out. Hired hands became tired of the slow gait, lost interest, cruelly deserted their employers and struck out on foot, or took a horse and went forward, in their haste to reach the new country. There was much suffering. Those who had food to spare willingly divided. Fathers and mothers died and left little children to the mercy of strangers. Some families lost all their cattle and had to depend on others as they struggled on, hoping to reach the promised land. Many gave up all hope. The weak and timid fell.*

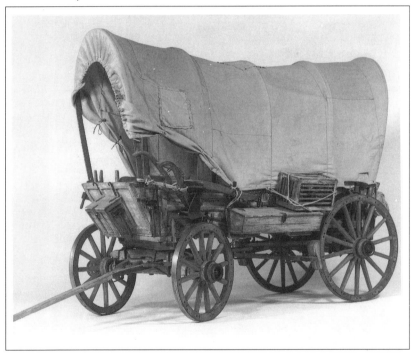

*"The wagons . . . were to be strong and the boxes made deep and well ironed off so they could be used, if necessary, as boats for crossing swollen streams,"* wrote Martha Gay Masterson. Her family crossed the country in four covered wagons much like this one.
(Courtesy Oregon Historical Society)

Despite these gloomy possibilities, the members of Martha's wagon train had a lively social life, especially the younger folks. In the evenings they gathered around their campfires to sing and tell stories. Cut off from the rest of the world, they relied upon each other for entertainment. Wrote Martha, "Everything was made much of that was amusing or interesting as we had no news or word from home. So we originated our own news and mirth."

The final push came in the Oregon Territory, when the emigrants had to cross the Cascade Mountains to reach the Willamette Valley. The wagon road up and down the steep slopes of Mt. Hood was narrow, clogged with impatient drivers, and muddied by a pelting rainstorm, but finally the Gays got through to the other side and staked out a homestead. Within a year or so, Martin Gay moved his family farther south to a ranch in the mountains near the present-day site of Eugene, Oregon. There he began building a large house that became the Gay family home. Martin and Ann Gay would never move again.

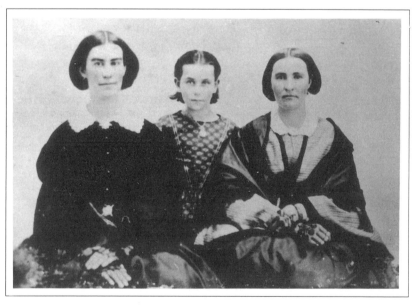

*The three Gay sisters: from left to right, Martha, Sarah Julia (Pink), and*
*Mary Frances (Mamie).*
(Courtesy Lois Barton and Spencer Butte Press)

Martha Gay must sometimes have wondered whether she too would spend the rest of her life in her parents' home. She had a wonderful time growing up there. She became an excellent rider and enjoyed exploring the countryside on horseback. She and her brothers and sisters made trips by stagecoach and steamboat to visit friends in other cities along the Willamette, and every summer there was great excitement when the Oregon State Fair was held not far from Eugene. The fairs recaptured some of the hardy pioneer spirit of the Oregon Trail crossing. "[They] were well worth going sixty miles to see," Martha remembered, "even if we did have to go in a wagon and camp out and do our own cooking. Hundreds of others were camped out around us, all feeling happy and independent while they enjoyed the fair." All kinds of machines were exhibited at the fairs: "Everything from an apple peeler to a locomotive. We were proud to see all this in our new country of Oregon."

As time went on, however, the big Gay family home grew empty. Martha's father died. Mamie married and moved away, and most of Martha's brothers, too, went off to start their own lives. Then Martha's beloved sister Pink died at the age of 19. "Our home was so lonely now," Martha wrote later, "I could not be satisfied there any more. I thought of going to a home of my own. . . ." That sentence is the only reference in Martha's autobiography to her courtship. Somehow she had become acquainted with a blacksmith named James Alfred Masterson, a widower with nine children, five of whom still lived at home. Masterson proposed to Martha, and in August of 1871 they were married. Masterson was 43 years of age. Martha was 33—fairly old for a bride, by the standards of a time when girls were often married in their teens.

"I could not say I was a happy bride," wrote Martha years later, "for I felt sad to leave [my mother] so lonely." Martha's account of the wedding is brief and contains a hint that the marriage failed to live up to her hopes: "On a quiet Sabbath morn, I took the solemn vow to love, honor and respect, and to trust one who might deceive me."

If Martha's life on the Gay farm had been quiet in recent years, her new life with Masterson was anything but dull. She became an instant mother to Masterson's children, the youngest of whom, Bess, was three years old. Her own first child, a boy named John Balf Masterson, was born in 1873 in Silverton, Oregon. At the time, Martha and her husband were managing a hotel in Silverton, running what Martha described as "a flourishing business."

The Mastersons might have stayed in Silverton and prospered, but Masterson was a rolling stone who could never stay in one place for very long. He had first come West in 1850 to seek a fortune in the gold fields of California; later, while crossing the Oregon Trail, he and his first wife survived an attack in which a number of emigrants were killed or kidnapped by Indians. His first wife died in 1870, and he married Martha the following year. She soon learned that he was a dreamer and a perpetual drifter, the kind of man for whom the western frontier was ideally suited. Each time he heard about a new settlement over the horizon, or a new opportunity to make money in some other town, he was ready to move. After living for 20 years in her comfortable family home, Martha may have favored the settled life, but if she yearned for a chance to put down roots of her own, she did not get one. She and Masterson moved 20 times in 20 years, crisscrossing the Pacific Northwest in Masterson's endless search for the perfect situation.

After a short time in Silverton, Martha had to go back home to nurse her mother through a spell of illness. When she returned to Silverton after a few days' absence, she discovered that her husband had gone to Canyon City in eastern Oregon on business. "He liked the country so much," said Martha, "that he wanted us to close out our business in Silverton and move to Canyon City." This was the first of many times that Masterson was to take off for some distant point, leaving Martha to handle the labor of selling out, packing up, and moving the family after him. She and the children were "very much opposed to the change," she reported, but they had little choice. Although it was the middle of winter, they made their "perilous way" by steamboat and ox-cart into the bleak, cold, windswept highlands of east-central Oregon. When they finally reached Canyon City, they were "sadly disappointed." Martha wrote, "We had hoped to see an inviting place, but instead we saw a little mining camp built in a narrow canyon." The country had a "wild, weird aspect," with "no trees in town and no gardens and very few flowers"—a landscape quite different from the lush, green, densely wooded hills of western Oregon from which they had come.

On her first day in Canyon City, Martha was devastated to receive a letter saying that her mother had died: "I felt that such news was a bad omen in our new home." She was right. "Our stay in Canyon City was not a happy one," she later wrote. Masterson went off to seek a milder climate, leaving Martha to take care of

the children. Their young son, John Balf, caught pneumonia and died after two weeks of intense suffering. Bess, too, was sick. Finally Martha received a summons from Masterson to join him back in the Willamette Valley. "We sold up and prepared to go," she wrote. "I was not opposed to going home, but how I regretted that we went to the mountains. We had lost our time, property and everything we possessed—our home and fine business and more precious than all, our dear child."

Martha bore a second son, Freddie, in 1875. Still restless, Masterson decided that a summer spent camping in the Cascade Mountains might restore his health and spirits. The experience was a grueling one for Martha, who had to look after several small children while trying to keep house in a tent. When the family came down from the mountains, Masterson went back to eastern Oregon to start a business, and Martha and the children spent the winter of 1876–77 with Martha's sister Mamie. Martha's third child, a girl named Frances Hortense, was born that winter.

In the spring, Masterson decided to move his family east, and Martha prepared the children for a long wagon trip across the Cascades. The trip was enlivened by the cougars who prowled hungrily around their camp at night and by the dangers of the narrow, winding road. Looking over the precipice, Martha could see dead horses and cattle below, relics of earlier road accidents.

The Mastersons lived briefly in several settlements in the Ochoco Valley of central Oregon. Martha never openly criticized her husband, but impatience and disillusionment crept into her account of that year:

> We stopped at Prineville, where husband thought of going into busi-
> ness. He changed his mind, left us in Prineville and went to the mines
> at Silver Springs. When he returned little Fred was very sick.

Trouble broke out between the white settlers and the Indians of central Oregon in the spring of 1878. Martha would lie in bed at night with her arms wrapped around her baby girl, listening for a "war whoop." Some of the Mastersons' acquaintances were killed in skirmishes with the Indians. Martha reported that women from the Indian villages sometimes came into the settlements to warn the white women that trouble was brewing. "Usually an Indian woman told the whites when the men were preparing for war," she wrote. "I think they preferred peace to war."

To the north, work was under way on an immense engineering project on the Columbia River: the construction of locks to carry ships around a dangerous stretch of falls and rapids. Masterson found work there, and from 1878 until 1882 the Mastersons lived along the river near the present-day site of the town of Cascade Locks. It was a sorrowful time for Martha, a time of "many disasters to us," she recalled years later. Martha ran a grocery store and later a boarding-house. "I did an extensive business for a year, then had to close on account of impaired health," she said. "There were so many boarders I found the work too difficult." While on the Columbia, Martha survived three house fires and a dangerous river crossing, but the worst blow was the death of her son Freddie in 1879. As was often the case when tragedy struck the family, Masterson was away at the time. Martha's sole comfort was an Indian girl whom she had hired as a servant. "How lonely I felt there with my dying child," she wrote.

In 1882, Masterson went to work for the Northern Pacific Railroad, which was building a line through eastern Oregon and Washington. Martha and the children once again spent a summer camping in the wilderness; in the fall Masterson found a home for them in Vancouver, Washington. The years that followed brought a series of moves. In 1883 the Mastersons went to Dayton in eastern Washington, where they "were well situated and had pleasant times," as Martha said. She liked living there, close to one of her brothers and his family, but soon word came that gold had been found in northern Idaho. Wrote Martha, "At last my husband, who was always ready to go on to a new field of labor, got the gold fever and insisted on going. I was very much opposed to leaving our pleasant home and nice surroundings. I insisted that he give up the wild idea, but he could not resist."

Instead of going to the mines, however, Masterson stopped on the shores of Lake Coeur d'Alene and decided to settle there. Martha fell in love with the lake: "A lovely, level country spread out for miles and the broad expanse of water lay as a front view, with tall mountains beyond it." She and her daughter and stepdaughter spent a happy year at the lake before Masterson moved them on to the gold mines. "We did not want to venture into the mines," Martha wrote. "We heard such doleful accounts about the dangerous roads and deep rivers and many other obstacles to encounter on the way. The journey was to be made part of the way on horseback and few women had ventured in over the almost impassable route. He insisted."

Reluctantly, Martha sold "our dear home" by the lake and moved to the mining camp. It was a rough life, but like most phases of Martha's married life, it did not last long. Masterson moved his family to Spokane, Washington, in 1886. They lived there for three years, long enough for Martha to marvel at "this prosperous new town," with "crowded streets," "throngs of people hurrying here and there," "magnificent buildings on every side," and "railroads too coming in on every side." Industry was booming, but Martha also noticed growing pollution, the dark side of progress: "The city was becoming very sickly, occasioned by the bad water. The outlet of the lake was not pure. The smelters were at the headwater of the lake and the minerals poisoned the water."

In 1889, Masterson moved the family back to northern Idaho. Then, in 1890, he took them first to the Puget Sound in western Washington and then to Centralia, south of Seattle. By now Bess was married, and the household consisted of Masterson, Martha, and their daughter Frances Hortense. While living in Centralia, Martha received a visit from her brother Jack, whom she had not seen in 23 years. Reflecting that his life had been spent peacefully on a farm near the Gay family homestead, she summed up her very different history in the following words:

> My own pathway on life's rugged road had been a winding and an eventful one. I seldom loved a friend or flower but that it was sure to fade and die. I often had prosperous homes and pleasant surroundings, but some unexpected event would call for a move to other parts. Sometimes we would better our conditions and surroundings financially, but oft times it was worse for us.

"After twenty years of wandering," as Martha put it, she wanted to return to her old home in Oregon. Masterson agreed to move back to the Willamette Valley, and Martha insisted that this was to be "the last move." As usual, he went on ahead. "A man is soon ready for a journey," Martha observed. "Packs his grip, gets his ticket and is off before a woman can decide on the color of her traveling dress. . . . We remained to sell out and pack up, as usual, and say goodbye to our neighbors."

Martha returned to Oregon in 1892. At this time she and her husband separated. He is not mentioned again in her autobiography, and he appears to have spent the years between 1892 and his death in 1908 living with his children from his first marriage. As for Martha and her daughter, they headed toward Eugene and the

farm where Martha had grown up. Sadly, though, many members of Martha's family had died during her years of wandering. Her autobiography ends on a somber note:

*Who would meet us in Eugene? Friends of other days had passed away. None of my brothers were near the old home. My sisters lay with my parents on the hill. Would my old home be a happy place to me now? What memories the old-time haunts would revive, days when we all gathered in the dear home.*

Martha was 55 when she came back to Eugene. She lived in Oregon for another 24 years, spending her final decade in the home of her daughter, Frances Hortense, and Frances's husband. Sadly, Frances had become something of an invalid, and despite her age and growing frailty Martha was responsible for much of the housekeeping. "I am feeling old and feeble," wrote Martha in her diary in 1916. "I am trying to do the work alone. It is tiresome for me as I am so weak." She died on December 12 of that year and was buried in the Gay family cemetery near her parents and sisters.

Martha Gay Masterson's life spanned an era of great change in American history—from an ox-cart journey on the Oregon Trail to World War I. She had seen the Northwestern frontier of ranches, mining camps, and Indian wars slowly tamed and made into a place of railways, streetlights, and industry. Her story is a testament to the lives of thousands of women who lived through a tumultuous time, striving diligently—often in the most difficult circumstances and with little personal freedom—to care for their families, to build homes and communities, and to keep the trials and triumphs of the past alive for younger generations.

# Chronology

| | |
|---|---|
| **1837** | Martha Gay born in Arkansas |
| **1838** | family moves to Missouri |
| **1851** | Gay family comes to Oregon Territory on Oregon Trail |
| **1871** | marries James Alfred Masterson in Oregon |
| **1875** | son John Balf dies |
| **1878–82** | Mastersons live along Columbia River; son Freddie dies in 1879 |
| **1882** | move to Washington |
| **1884** | move to Idaho |
| **1886** | move to Washington |
| **1889** | move to Idaho |
| **1890** | move to Washington |
| **1892** | Martha and her daughter return to Oregon |
| **December 12, 1916** | Martha Gay Masterson dies in Eugene |

# Further Reading

Barton, Lois. *One Woman's West*. 2nd edition. Eugene, Or.: Spencer Butte Press, 1990. Martha Gay Masterson's autobiography, edited by a historical writer and researcher; highly readable and well illustrated.

# Elinore Pruitt Stewart
# The Woman Homesteader
# (1876–1933)

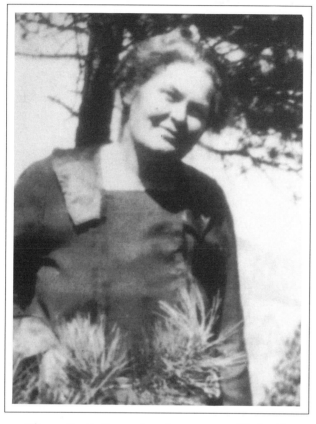

*Elinore Pruitt Stewart's early years were filled with
poverty, grief, and hard work. She dreamed of living an
adventurous, independent life and fulfilled that dream by
homesteading in southwestern Wyoming.*
(Courtesy Elinore Pruitt Stewart Estate)

*T*he western frontier offered women new freedoms. Although
American women of the nineteenth century were neither legally
nor economically the equals of men, the barriers to equality began

falling—and they fell first in the West. In 1869, Wyoming became the first state to allow women to vote; Utah was the second, in 1870. Women had won the right to vote in every western state by 1914, although they could not vote in national elections until 1920.

Far from their parents and the communities in which they had grown up, women took on new roles in the West. They ran family farms, operated businesses, and managed their own money and property. And after President Abraham Lincoln signed the Homestead Act in 1862, they staked claims to land of their own. According to Cathy Luchetti and Carol Olwell, authors of *Women of the West*, the homestead laws of the mid-nineteenth century "made land available to single women for the first time in history."

Women who wanted an independent, self-supporting way of life took advantage of the homesteading laws to establish themselves as property owners. Some states encouraged single women and widows to file homestead claims, believing that the presence of hard-working women would have a stabilizing, civilizing influence on the wild frontier. Historian Joan Swallow reports in her book *The Women* that by 1910, one-tenth of all homesteaders were women. They were successful, too. Suffragist Harriet Strong declared that "it takes brains, not brawn, to make farms pay," and added "We need more women farmers!"

One woman who claimed land in Wyoming became known to readers all over the country as *The Woman Homesteader* when the letters she had written to friends from her homestead were published in a national magazine and later in book form. But although Elinore Pruitt Stewart's readers delighted in her lively, compassionate, colorful descriptions of her frontier neighbors and adventures, they knew nothing of the hardships she encountered in private life.

───────

Elinore Pruitt was born on June 3, 1876, at White Bead Hill, on land belonging to the Chickasaw Nation in Oklahoma's Indian Territory. Elinore's grandmother, Mary Ann Courtney, had been living in Indian Territory for some time and may have been one-half Chickasaw. Elinore's father, a man named Pruitt, was in the army and was killed on the Mexican border while she was quite young. Elinore's mother then married her late husband's brother.

They had seven children—younger half-brothers and half-sisters for Elinore.

The Pruitt family was desperately poor. Elinore later claimed that she did not even own a pair of shoes until she was six years old. She had very little formal schooling and taught herself to read and write by studying every scrap of writing she could find and by asking questions of the local storekeeper. Elinore's mother died in January 1893, when Elinore was 17 years old. Her stepfather arranged marriages for two of his daughters, despite the fact that they were only 12 and 13 years old; it is not known whether he also tried to marry off Elinore. He died a year later, leaving Elinore to take care of the five remaining children, who were between the ages of ten and two. They spent a few years with their widowed grandmother, and then the older children went to work for the Santa Fe Railroad. Elinore and Josephine, her oldest half-sister, did laundry for the crew that was laying track through that part of Oklahoma. The boys dispersed: one died, one went to work on a farm, and one went west. Elinore's two half-sisters moved to California a few years later.

Around 1902, Elinore Pruitt married a man named Harry Cramer Rupert and together they homesteaded a parcel of land in Oklahoma. By 1906, however, Elinore was living in Oklahoma City without Harry. There she gave birth to their daughter Jerrine. There are no records of Elinore's marriage to and divorce from Harry Rupert. Official record-keeping was a hit-or-miss business in many frontier communities, and even when records were kept, they were sometimes destroyed later by courthouse fires. It is even possible that Elinore never married Rupert at all. After their separation she told everyone that her husband had died in a train wreck, although in reality he went on living in Oklahoma and later remarried. In the early years of the twentieth century, being divorced was considered almost as scandalous as having a child out of wedlock, and as a young woman with a daughter to support, Elinore must have realized that prospective employers would look more kindly on her if they thought she was a widow.

Elinore had a passion for writing. She wrote a few newspaper articles that were published in the *Kansas City Star* and dreamed of becoming a travel writer. A few years later she described her ambitions this way:

*I had not thought I should ever marry again. Jerrine was always such a dear little pal, and I wanted to just knock about foot-loose and free to see life as a gypsy sees it. I had planned to see the Cliff-Dwellers' home; to live right there until I caught the spirit of the surroundings enough to live over their lives in imagination anyway. I had planned to see the old missions and to go to Alaska; to hunt in Canada. I even dreamed of Honolulu. Life stretched out before me one long, happy jaunt. I aimed to see all the world I could, but to travel unknown bypaths to do it.*

The need to make a living for herself and Jerrine forced Elinore to give up her dream of travel. She moved to Denver and went to work as a servant. By great good fortune, she was hired by a kindly, crippled older woman, Juliet Coney, who became a lifelong friend.

Soon Elinore had a new dream. Tired of the "rattle and bang, of the glare and the soot, the smells and the hurry" of the city, she longed to live in "the sweet, free open" among pine trees. She decided to homestead a land claim. A priest to whom she turned for advice suggested that she work for a rancher in order to learn about the homestead laws and about running a farm. In March of 1909 Elinore saw an ad in the *Denver Post*: "WANTED—Young or middle-aged lady as companion and to assist with housework on Wyoming ranch; a good permanent home for right party."

The ad had been placed by Clyde Stewart, a widower who lived on a ranch in Burntfork in southwestern Wyoming, just north of the Utah border and 60 miles from Green River, the nearest city. Elinore and Clyde met in Denver and approved of one another, and Clyde took Elinore and Jerrine back to Burntfork with him. Although Elinore was hired as a housekeeper, eight weeks later she and Clyde were married. The wedding took place in Clyde's ranch house. Elinore had bought a fine pair of new shoes for the occasion, but the guests arrived before she was ready, and she forgot to change her shoes. "All I can remember very distinctly," she wrote later, "is hearing Mr. Stewart saying, 'I will,' and myself chiming in that I would, too. Happening to glance down, I saw that I had forgotten to take off my apron or my old shoes, but just then Mr. Pearson pronounced us man and wife."

The marriage was a tremendous success, with a solid foundation of affection and good humor on both sides. Elinore bore five children within four years; she joked that they were born so close together that they came out holding each other's ankles. Two of the babies died in infancy; three boys survived. The birth of

Robert, her last child, was particularly hard on Elinore. The hired girl who was supposed to assist her eloped instead, so Elinore had no one to help her but her husband, and she had to tell him how to help deliver the baby. He felt so weak and shaken after assisting in Robert's birth that he had to make himself a sandwich before he could help her wash and dress the baby.

Elinore's marriage had not distracted her from her goal of owning her own homestead. Several months after arriving in Burntfork she filed a claim on a 160-acre parcel of land next to Clyde Stewart's property. She was happy that her claim had a grove of 12 pines on it: "I had thought it would be very romantic to live in the peaks amid the whispering pines," she wrote to Juliet Coney, "but I reckon it would be powerfully uncomfortable also, and I guess my twelve can whisper enough for me."

Under the law, Elinore had to build a house on her claim and live in it for five years. Fortunately, her property line was only two feet from Clyde's house, so she was able to build her own house adjoining his. In that way she satisfied the requirements of the homestead law but still lived under the same roof as her husband.

*The Stewarts' long, narrow ranch house, built in several stages over the years, straddled the boundary line between Clyde's claim and Elinore's.*
(Courtesy Elinore Pruitt Stewart Estate)

Her letters to Juliet Coney reveal great pride in her new home, especially in the fact that she managed it herself:

> *I should not have married if Clyde had not promised I should meet all my land difficulties unaided. I wanted the fun and the experience. For that reason I want to earn every cent that goes into my own land and improvements myself. Sometimes I almost have a brain-storm wondering how I am going to do it, but I know I shall succeed; other women have succeeded. I know of several who are now where they can laugh at past trials.*

The letters Elinore wrote to Juliet Coney were chatty, funny, and vividly descriptive, filled with incidents of life on the Stewart ranch and with tales of the eccentric folk who lived in Burntfork and the surrounding mountains: moonshiners, miners, cowboys, highwaymen, and more. Elinore's biographer Susanne K. George believes that Elinore was consciously writing for publication, hoping that her letters would one day reach a wider audience. Elinore blended fiction with fact in her letters, so that they cannot all be read as strictly accurate accounts of her own experience. It is more accurate to think of them as autobiography molded by a creative imagination.

Many of Elinore's letters celebrated the glories of nature. In one she described a sunset: "It seemed as if we were driving through a golden haze. The violet shadows were creeping up between the hills, while away back of us the snow-capped peaks were catching the sun's last rays. On every side of us stretched the poor, hopeless, desert, the sage, grim and determined to live in spite of starvation, and the great, bare, desolate buttes. The beautiful colors turned to amber and rose, and then to the general tone, dull gray." Other letters dealt with Elinore's own adventures—and misadventures, as when she took Jerrine up into the mountains for what was supposed to be a simple overnight fishing trip until an unexpected snowfall stranded them high on a peak. They found salvation in the form of an old homesteader who welcomed them into his cabin and reminisced about life in the South in the good old days before the Civil War.

Juliet Coney took Elinore's letters with her on a visit to the East Coast and showed them to her friend Ellery Sedgwick, who was the editor of the *Atlantic Monthly*, an influential literary magazine. Sedgwick was charmed by the letters and began publishing them in his magazine in 1913. They were collected into a book called

*Clyde and Elinore Stewart, about 1921. Clyde had bet Elinore five dollars that he could find a weed in her garden. He failed to find one but had hidden a weed in his pocket for just such an emergency. Elinore, however, proved too clever for him and picked his pocket.*
(Courtesy Elinore Pruitt Stewart Estate)

*Letters of a Woman Homesteader*, which was published in 1914; a second series of articles was published in book form under the title *Letters on an Elk Hunt* in 1915.

Elinore's literary career brought her both satisfaction and frustration. The money she received for the articles and books was very welcome, for it was hard work making money out of the ranch. Elinore used the first money she earned to buy a gasoline lamp to light up the room so that she could read and write at night. The admiration she received from readers and reviewers was welcome, too, especially to an author who had struggled to educate herself. The publication of her work brought Elinore into a wider world and relieved the loneliness she sometimes felt on the ranch. Some of the people who wrote to Elinore to tell her how much they enjoyed her books became close friends with whom she corresponded for the rest of her life.

Yet Elinore was frustrated when her writing career stalled after *Letters on an Elk Hunt*. She wanted to tell stories, but the *Atlantic Monthly* repeatedly turned down her efforts; not until 1919 did they publish another "letter" from the woman homesteader. Elinore wrote a few stories for a children's magazine, but her most ambitious project was a novel of western adventure called *Sand and Sage*. She was unable to find a publisher for it, however, and her daughter Jerrine reported that once, full of dejection, she started to burn the manuscript in the stove.

Around the time that Elinore's books were published, the Stewarts began spending the winters in Boulder, Colorado, so that the children could attend a good school. For a time, the family returned to the ranch each summer. Starting around 1920, they experienced both money and medical troubles. They could no longer afford two households, so they leased out the land in Wyoming to a tenant and lived year-round in Boulder until 1925, when they returned to Burntfork.

Elinore had always been proud of the fact that she knew how to operate a mowing machine, but in the fall of 1927 she was nearly killed while mowing: An owl spooked the horses that were pulling the mower, and Elinore was thrown under their hooves. She suffered multiple injuries, was bedridden for months, and never fully regained her health. At the same time, as she revealed in a letter to a friend, she was greatly worried about her husband. His behavior had become so erratic that she feared he was going insane. Fortunately, he recovered, and Elinore's worries about

*"Among the things I learned to do was the way to run a mowing-machine,"*
*wrote Elinore. She is pictured here driving the hay mower in the mid-1920s,*
*not long before she was seriously injured in a mowing accident.*
(Courtesy Elinore Pruitt Stewart Estate)

him subsided; the family later learned that he suffered from a blood-sugar disorder that affected his mental state.

Elinore's accident ended her adventuring days. In 1929 she confided to one correspondent, "It is almost certain that I shall not be able to leave the place to hunt for an adventure. . . ." Later, writing to another friend about the joys of gardening, Elinore recalled how in her early years of homesteading she had experimented each year to find what kinds of flowers would grow in the mountain climate. These were "the years of happiness to remember when I get so I can't hoe and dig."

In the spring of 1933, Elinore's family took her up into the mountains to camp at a place called "the Cedars," one of her favorite spots. In the days that followed, Elinore looked back over her life and shared her thoughts in a long, rambling letter with one of her correspondents: "I have had more than half a century of such happiness. A great deal of worry and sorrow, too, but never a worry or sorrow that was not offset by a purple iris, a lark, a

bluebird, or a dewy morning glory. Until this spring . . . I suddenly lost courage. . . . I am not afraid, there is nothing to fear, but I couldn't sleep at all last night. The wind blew and a tent can make so many queer noises. Many times it sounded as if someone was crawling in. But at last morning came, and I heard a lark as soon as I stepped outside."

Later that year, on October 8, Elinore Pruitt Stewart died at the age of 57 from a blood clot on the brain. She left as a legacy her two volumes of letters, a quantity of unpublished stories and letters, and the example of a woman who followed her dream. "I am very enthusiastic about women homesteading," she had written in 1913, adding that "any woman who can stand her own company, can see the beauty of the sunset, loves growing things, and is willing to put in as much time at careful labor as she does over the washtub, will certainly succeed; will have independence, plenty to eat all the time, and a home of her own in the end."

# Chronology

| | |
|---|---|
| **June 3, 1876** | Elinore Pruitt born at White Bead Hill in Indian Territory, Oklahoma |
| **January 1893** | Elinore's mother dies |
| **1894** | Elinore's father dies |
| **1902 (?)** | marries Harry Rupert |
| **1906** | daughter Jerrine born |
| **1909** | moves to Wyoming; marries Clyde Stewart; files homestead claim |
| **1913** | begins publishing articles in *Atlantic Monthly* |
| **1914** | *Letters of a Woman Homesteader* published |
| **1915** | *Letters on an Elk Hunt* published |
| **1927** | injured in a mowing machine accident |
| **October 8, 1933** | Elinore Pruitt Stewart dies in Rock Springs, Wyoming |

# Further Reading

George, Susanne K. *The Adventures of the Woman Homesteader: The Life and Letters of Elinore Pruitt Stewart*. Lincoln: University of Nebraska Press, 1992. A collection of previously unpublished letters and stories by Elinore Pruitt Stewart; includes the most detailed biography available, based on recollections by Elinore's descendants.

Luchetti, Cathy and Carol Olwell. *Women of the West*. New York: Orion Books, 1982. Contains a chapter on Elinore Pruitt Stewart with lengthy excerpts from *Letters of a Woman Homesteader*.

Smith, Sherry. "Single Women Homesteaders: The Perplexing Case of Elinore Pruitt Stewart." *Western Historical Quarterly*, May 1991. A detailed look at the homesteading laws and how they applied to Elinore Pruitt Stewart's land claim; too scholarly for general readers.

Stewart, Elinore Pruitt. *Letters of a Woman Homesteader*. Lincoln: University of Nebraska Press, 1989. Originally published in 1914.

———. *Letters on an Elk Hunt*. Lincoln: University of Nebraska Press, 1979. Originally published in 1915.

# Polly Bemis
# "China Polly" of Idaho
# (1853–1933)

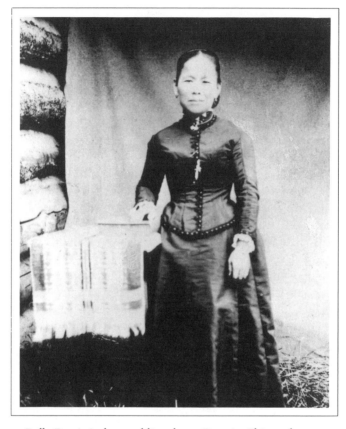

*Polly Bemis in her wedding dress. Born in China, she was*
*sold into slavery as a child and brought to the United States*
*as a prostitute. Luckier or pluckier than most of those who*
*shared this fate, Polly married and found a new life in*
*frontier community.*
(Idaho State Historical Society #75-228.43/h)

Some pioneer women left no letters or diaries. Some of them had
no one to whom they could tell their stories; others did not know
how to write. Their histories are known to us only from the
outside, and only in a sketchy, fragmentary way, through the

recollections and observations of other people. This is especially true of Asian women in the West. Most of what we know about them comes from anecdotes told by people who knew them. Such stories are likely to have been distorted by the passage of time or by the teller's natural desire to embroider a plain narrative with some colorful details. At the distance of a century or more, it is sometimes difficult to sort out fact from fiction in the lives of the pioneer women who were among the first Asian Americans. Many of them lived and died in obscurity. But some, like Polly Bemis, became well-known figures in their communities.

---

Polly was born Lalu Nathoy in northern China in 1853. Very little is known about her childhood and early life. At some point, possibly in her teens, her parents gave her to bandits in exchange for some food. Famine was raging in China at the time, and it was not unusual for desperate parents to sell their daughters for a little money or food to help the rest of the family stay alive. Most of these unfortunate girls were destined for a life of slavery or prostitution.

Nathoy was shipped to San Francisco, probably around 1872, as part of the growing trade in Chinese prostitutes. The women were forced to sign contracts that bound them to a life of virtual slavery. Although Christian missionaries managed to rescue some of the prostitutes from San Francisco's Chinatown, for the most part the Chinese women were cut off from the larger society by the language barrier and by cultural differences. Closely guarded, locked inside brothels, they had few opportunities to escape or to seek protection under the law. Sometimes, when they did escape, the law returned them to their owners, saying that their labor contracts must be honored. For most of the Chinese prostitutes, the only escapes were drug or alcohol abuse, mental illness, disease, and death. There were exceptions. Some of the women were purchased by kind, affectionate owners, and a few survived the rigors of their fate to win their freedom.

Upon arriving in San Francisco, Nathoy was sold at an auction in San Francisco and taken on muleback to Warrens, a small town along the Salmon River in central Idaho. In the mid-1860s gold was discovered in the region, and miners had swarmed in from all over the country. Central Idaho was and is extremely rugged, with heavy snowfalls and terrain that consists of steep, densely

wooded mountains and deep, narrow gorges. In the 1870s the area was sparsely inhabited—except for the thousands of men who had come to pan for gold in the mountain streams. Saloons, gambling halls, and brothels sprang up overnight to relieve the miners of their gold dust. Nathoy's new owner was a Chinese man who operated a "dance hall" on the main street of Warrens. Although the women who worked for him were called dancing girls, in reality they were prostitutes. Nathoy was one of several Chinese women in the establishment. She was given a more American-sounding name, Polly. The men called her "China Polly."

Next door to the dance hall was a gambling hall run by a man names Charles Bemis, a quiet, easy-going, rather lazy fellow who had come from Boston hoping to make his fortune in gold but who discovered that he was better suited to gambling. Bemis and Polly became friends. According to the reminiscences of an old- time Warrens resident named George Bancroft, Polly used to tidy up Bemis's messy room. She also came to rely on Bemis for protection. "When things got too rough in the dance hall," Bancroft said, "she used to fly out the back door and into Bemis's back door, or, if unable to do this, she used to call Bemis and he never failed her. His quiet, sober, stern personality together with his reputation for being able to keep a can rolling with his six-shooter saved Polly from several very threatening situations."

At some point, possibly in the late 1870s, Polly won her freedom. The most frequently told version of the story is that Charlie Bemis won her from her owner in a card game and then pronounced her free. But it is also possible that Polly bought her freedom, or helped Charlie to do so, for she had taught herself to make jewelry and had managed to accumulate some money by selling the buttons and ornaments she fashioned out of gold. After leaving the dance hall, Polly ran a boardinghouse next to Bemis's gambling hall and continued her goldsmithing work. Always ready to help others, Polly soon made friends with the married women and children of the community and was well liked by everyone. She often helped out when someone was sick, for she was a good nurse and possessed some skill in the use of herbal medicines.

Charlie Bemis's "great reputation for square dealing," Bancroft recalled, "brought him certain responsibilities which were not entirely pleasing." Some of the local miners and cowboys got into the habit of entrusting Bemis with their gold dust or money before they went on drinking sprees, knowing that their hoards would be safe

with Bemis. He installed a large safe to hold these "deposits."

One night a miner gave Bemis several buckskin pouches of gold dust and made Bemis promise not to give them back to him until he was completely sober. Bemis agreed and put the dust into his safe. At midnight the miner returned, far from sober, and demanded his dust. Bemis sent him away. He came back at two-thirty in the morning, still drunk. Once again Bemis sent him away and told him to return when he had sobered up. At six in the morning the man climbed through Bemis's bedroom window, woke Bemis up, and threatened to shoot him unless he received his gold dust at once. Seeing that the man was still drunk, Bemis told him to come back later. The miner sat down in a chair, lit a cigarette, and said, "If you don't give me my dust before I finish this cigarette, I'll shoot your eye out." Bemis dismissed the threat as the ravings of a drunkard and went back to sleep. A few minutes later, his cigarette finished, the miner shot Bemis in the head. He missed the eye but sent a bullet plowing through Bemis's right cheek.

"Polly heard the shot and came running over," said Bancroft. "She aroused the town marshal and got the doctor." Although Bemis could not speak, he wrote down the name of his attacker, and the marshal, feeling that it would be a waste of public funds to arrest and try the fellow, simply rode after him and shot him dead.

"The doctor said Bemis was fatally shot," Bancroft later recalled. "There was no good of doing anything, just let him die peacefully, but Polly didn't think so. She knew something of Chinese cures. She bathed the wound and put extracts of herbs in it to stop the bleeding. For two weeks, day nor night, she never left his side, then the fever went down and he began to get better. Then one day Polly found the bullet embedded in the flesh at the back of the neck. Bemis was so cross at the doctor for refusing to do anything to try to save his life that he would not have him come near the room, so Polly, the dancing girl, got a razor and cut out the bullet."

Bemis made a complete recovery. He and Polly were married soon afterward, on August 13, 1894. They decided to leave Warrens and homestead a small patch of land along the Salmon River, in the bottom of a deep canyon. Hemmed in by the rock wall of the canyon and the rushing river, the claim had only 15 acres of farmable land, but the Bemises made it into a comfortable garden. They built a two-story cabin and Polly grew plums, pears, peaches, apples, tobacco, grapes, cherries, strawberries, corn, squash, melons, and more. Visitors were sent home with packages of fresh or preserved

# Polly Bemis

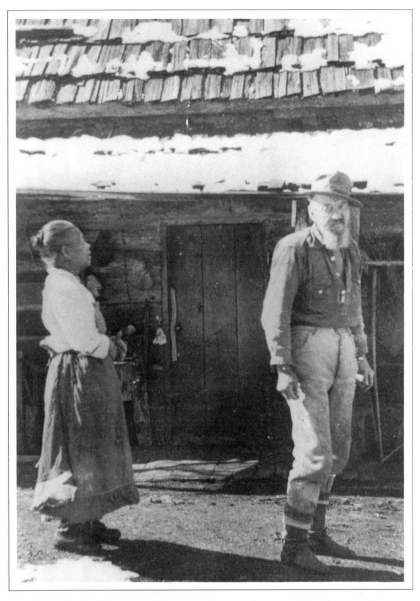

*Polly with Charlie Bemis, the man who may have won her in a card game and later married her, outside their cabin. Polly twice saved Charlie's life and also used her knowledge of herbal medicine to help their neighbors.*
(Idaho State Historical Society #62-44.4)

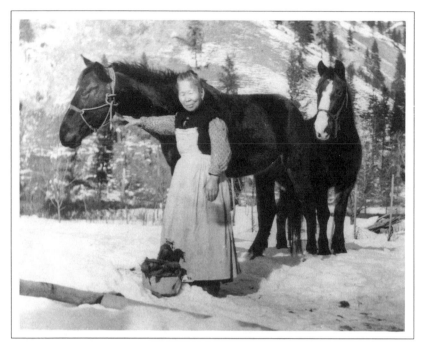

*Homesteading in Idaho was a hard life—but a free one.*
(Idaho State Historical Society #62-44.7)

---

fruit and vegetables. "Every time a wandering trapper or prospector came to the Bemis farm he was not only sure of a hospitable welcome on the part of Bemis but he was also sure to be loaded down with pies and cakes to be delivered to Polly's old friends," according to Bancroft. Polly made a special point of sending gifts of food to anyone she heard was sick. Several times sick or injured men were brought to the farm to be nursed back to health by Polly.

Visitors were welcome, for the Bemises had no neighbors in the canyon. "A more lonely place can scarcely be imagined," Bancroft said. "The canyon was never successfully navigated until 1918, so there was no traffic going up and down the river. . . . But Polly was supremely happy. She got some chickens and some ducks and a cow." She also took up fishing and became very good at it.

The canyon became less lonely around 1899 or 1900, when Charles Shepp and Pete Klinkhammer, who had been prospecting

in the Yukon, wandered into central Idaho and homesteaded on a claim right across the river from the Bemis farm. They built a rowboat so that travelers could cross the Salmon River between their farm and the Bemises'; as a result, more people began passing through the canyon, and Polly was delighted to have more company. Later Shepp ran a telephone line across the river so that the miners and the Bemises could talk. "This was a never-ending source of delight to Polly," Bancroft said. "The day was not complete unless she used it at least once." She loved to chat with Shepp and Klinkhammer about how many eggs her hens had laid or the size of a trout she had caught in the river.

Bemis died in 1922, and Polly left the canyon, but after a few years in Warrens and in nearby Grangeville she grew homesick for the farm. Returning to her home in the canyon, she was warmly welcomed by Shepp and Klinkhammer, who helped her with her chores now that she was becoming old and a bit weak. Polly fell ill in 1933 and was taken to the hospital in Grangeville. There she died on November 6 at the age of 80. Although she had wanted to be buried in the canyon next to Charlie, the deep snow made the canyon trail impassable, and she was buried in Grangeville. The city council acted as pallbearers at her funeral, for "China Polly" had become, as Bancroft said, "one of the most beloved women in central Idaho."

# Chronology

| | |
|---:|:---|
| **1853** | Lalu Nathoy born in northern China |
| **c. 1872 (?)** | brought to United States |
| **c. late 1870s** | is freed |
| **c. early 1890s** | Charles Bemis is shot in the face; Polly nurses him back to health |
| **August 13, 1894** | marries Bemis |
| **1922** | Bemis dies |
| **November 6, 1933** | Polly Bemis dies in Grangeville, Idaho |

# Further Reading

Luchetti, Cathy and Carol Olwell. *Women of the West*. New York: Orion Books, 1982. Contains a good section on Chinese women in the Old West, although no information about Polly Bemis.

McCunn, Ruthanne Lum. *Thousand Pieces of Gold*. San Francisco: Design Enterprises, 1981. A fictionalized version of Polly Bemis's life; based on historical research and interviews with people who knew Polly, but largely imaginative, especially the account of her early life.

Yung, Judy. *Chinese Women in America: A Pictorial History*. Seattle: University of Washington Press, 1986. An excellent illustrated history of Chinese women's lives in the United States from the early nineteenth century to the mid-twentieth; includes a short biography of Polly Bemis.

# INDEX

Bold numbers indicate main headings.
*Italic* numbers indicate illustrations.

New York (state) 83
New York City 49, 55
North, the 73
North Dakota xii, xiii
Northern Pacific Railroad
90
Northwest U.S.
and Martha Gay Master-
son 83, 88, 92

**O**

Ochoco Valley (Oregon) 89
Oklahoma, and Elinore
Pruitt Stewart 96–97
Old College Hall (Forest
Grove, Oregon) 36
Olwell, Carol 96
Omaha, Nebraska 56
Oregon xi–xii, xiii
and Martha Gay Master-
son 83, 86–90, 91–92
and Tabitha Brown 31,
32–34
Oregon City 32
Oregon legislature 37
Oregon State Fair 87
Oregon Territory
and Martha Gay Master-
son 83–84, 86
and Tabitha Brown 30,
31, 35
Oregon Trail xii, 19, 87
accounts of life on xv,
85
and James Alfred Mas-
terson 88
and Martha Gay Master-
son 83, 84–86, 92
and Orus Brown 34

and Tabitha Brown 30,
31, 32
Orphan Asylum (Forest
Grove, Oregon) 35

**P**

Pacific Northwest 83, 88,
92
Pacific Ocean xi, 41
Pacific University (Forest
Grove, Oregon) 35, 36
Pacific University Mu-
seum 37
Paiute Indians 21–22
Pamelia Township, New
York 54
Panic of 1857 56
Pawnee Indians 30
Phillips family 6, 7
Phillips' Ferry 5–6, 12
Pike County, Illinois 3, 14
Pikes Peak, Colorado 56,
74
Pioneer Cemetery (Salem,
Oregon) 37
*Pioneer, The* (magazine) 50
Platte River 19, 31
Portland, Oregon 67
Prineville, Oregon 89
Pringle, Virgil 30, 34, 36
accounts of cross-coun-
try journey 31–33
prostitution 108, 109
Pruitt, Elinore *See* Stewart,
Elinore Pruitt
Pruitt, Josephine (stepsister
of Elinore Pruitt Stewart)
97
Puget Sound (Washington)
91

# Women Pioneers

U.S. Congress xii
Utah xiii
    and Donner Party 20
    and Elinore Pruitt Stewart 96

**V**

Vancouver, Washington 90
Virgin Islands 4
Virginia 76
Virginia City, Montana 61, 64

**W**

Wagon Trains
    joined by Donner Party 18–23
    joined by James Alfred Masterson 88
    joined by James Fergus 56, 59
    joined by Martha Gay Masterson 84–86, *85*
    joined by Pamelia Fergus 63
    joined by Tabitha Brown 30–34
Warrens, Idaho 108–110, 113
Wasatch Mountains 20, 21
Washington xiii
    and Martha Gay Masterson 90, 91
    and Tabitha Brown 31, 32
Washington, D.C. 55
West Indies 4
"Western fever" 83
westward expansion
    into Colorado xii
    into Great Plains xii–xiii
    men's accounts of xv, 31–33
    participants of xiv
    role of women in xiv–xv
    into Southwest U.S. xii
    to the Pacific coast xi–xii
White Bead Hill (Oklahoma) 96
Willamette River (Oregon) 87
Willamette Valley (Oregon) xii
    and Martha Gay Masterson 84, 86, 89, 91–92
    and Tabitha Brown 32, 34
Wind River Mountains 63
Wisconsin xiii
Wolfinger (Donner Party member) 21
*Woman Homesteader, The* (Elinore Pruitt Stewart) 96
*Women of the West* (Cathy Luchetti and Carol Olwell) 96
*Women, The* (Joan Swallow) 96
women's right to vote 96
Woodworth (U. S. Army officer) 23
Wyoming xii, xiii, 31
    and Donner Party 19
    and Elinore Pruitt Stewart 96, 98–104

**Y**

Yellowstone River 63
Yorkshire, England 2–3, 4, 9, 11, 14
Yukon Territory (Canada) 67, 113